GW01043833

SACRED AND PROFANE

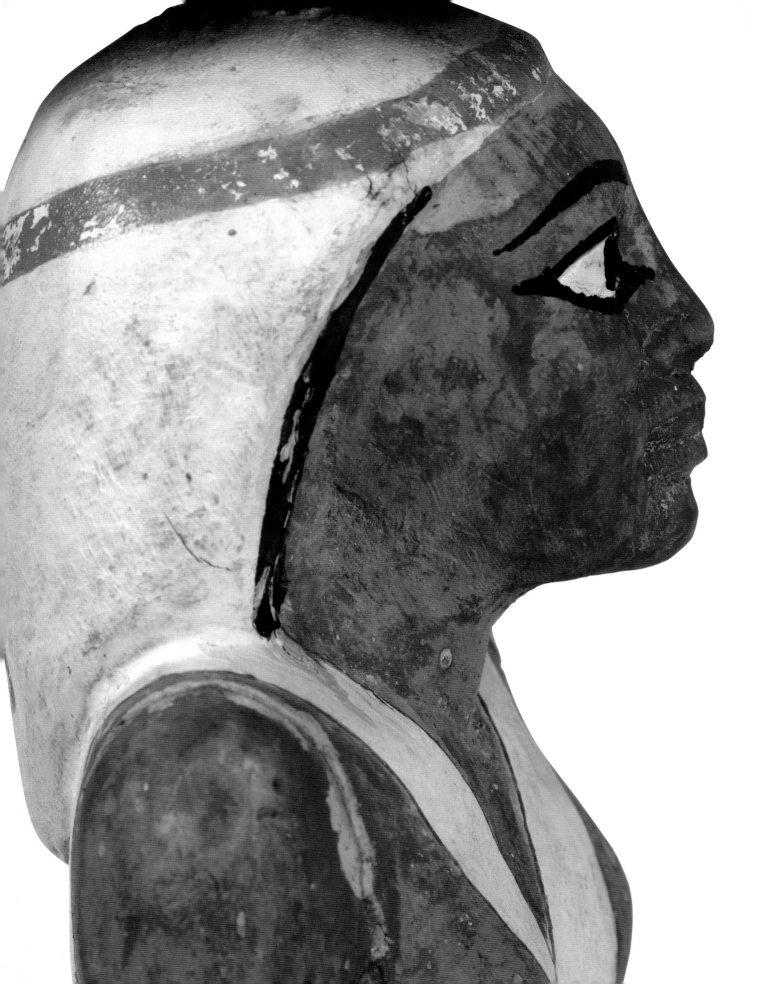

SACRED AND PROFANE

Treasures of Ancient Egypt from the Myers Collection,
Eton College and University of Birmingham

Edited by Eurydice Georganteli and Martin Bommas

UNIVERSITY OF
BIRMINGHAM

The BARBER
Institute of Fine Arts

g

The University of Birmingham and the Provost and Fellows of Eton College
in association with D Giles Limited, London

This publication accompanies the exhibition *The Sacred and the Profane: Treasures of Ancient Egypt from the Myers Collection, Eton College and University of Birmingham* on display at the Barber Institute of Fine Arts, University of Birmingham from June 2010 – January 2012

First published in 2010 by GILES
An imprint of D Giles Limited
4 Crescent Stables, 139 Upper Richmond Road,
London SW15 2TN, UK
www.gilesltd.com

ISBN: 978-0-704427-37-2 (Softcover edition)
ISBN: 978-1-904832-80-5 (Hardcover edition)

For the University of Birmingham:
Project Manager: Eurydice Georganteli
Project Editors: Eurydice Georganteli and Martin Bommas
Photographs are by Graham Norrie and Oxford Imaging Ltd

For D Giles Limited:
Copy-edited and proof-read by David Rose
Designed by Mercer Design, London
Produced by GILES, an imprint of D Giles Limited, London
Printed and bound by in China

All measurements are in centimetres

Front cover: Mummy mask made of gilded cartonnage (detail), Middle Kingdom (12th Dynasty), 23 × 18 × 8cm., *Myers Collection at Eton College, ECM 2165.*

Back cover (hardcover edition): Clockwise from top left: Reverse of a bronze drachm of Emperor Commodus (*reg* AD 180–92), mint of Alexandria, *The Barber Institute Coin Collection, RE367;* obverse of a silver tetradrachm of Ptolemy I (323–283/2 BC, *reg* 305–283/2 BC), mint of Alexandria, *The Barber Institute Coin Collection, G13;* reverse of a silver denarius of Mark Antony, struck at a moving mint in the East in 32 BC, *The Barber Institute Coin Collection, R809;* obverse of a gold solidus of Emperor Herakleios (*reg* AD 610–41), mint of Alexandria, *The Barber Institute Coin Collection, B2749;* reverse of a silver denarius of Emperor Hadrian (*reg* AD 117–38), mint of Rome, *The Barber Institute Coin Collection, R1133.*

Back cover (softcover edition): From top to bottom: Reverse of a bronze drachm of Emperor Commodus (*reg* AD 180–92), mint of Alexandria, *The Barber Institute Coin Collection, RE367;* obverse of a silver tetradrachm of Ptolemy I (323–283/2 BC, *reg* 305–283/2 BC), mint of Alexandria, *The Barber Institute Coin Collection, G13;* obverse of a gold solidus of Emperor Herakleios (*reg* AD 610–641), mint of Alexandria, *The Barber Institute Coin Collection, B2749;* reverse of a silver denarius of Emperor Hadrian (*reg* AD 117–138), mint of Rome, *The Barber Institute Coin Collection, R1133.*

Frontispiece: Female offering-bearer of Hapikem (detail), Late Old Kingdom, 45 x 20 x 20 cm., *Myers Collection at Eton College, ECM 1591.*

Contents

Forewords

The Myers Collection of Egyptian antiquities at Eton College is not only a superb assemblage of ancient Egyptian decorative art but also a window into the distant world of travellers in nineteenth-century Egypt and the Middle East. Educated at Eton College and Sandhurst, Major William Joseph Myers (1858–1899) started collecting in Egypt in the 1880s. Egypt was then a magnet for painters, novelists, archaeologists, collectors and adventurers and it was in Cairo that Verdi's Egyptian-themed *Aïda* opened in 1871. Spectacular archaeological discoveries were regularly made and throwing mummy unwrapping parties was fashionable in both Europe and America. On Myers's untimely death in 1899 Eton College became the beneficiary of his collection, diaries and library. The exhibition *Sacred and Profane* at the Barber Institute of Fine Arts celebrates this major bequest and launches a long-term collaboration between the University of Birmingham, Eton College and Johns Hopkins University. The present publication is the result of meticulous research on this little-known collection produced in the collegial and interdisciplinary environment of the College of Arts and Law and the Barber Institute of Fine Arts. The five essays that follow provide a fascinating discussion of the material culture related to the sacred and profane in Egypt from the fourth millennium BC to the seventh century AD, and of travel and archaeology in nineteenth-century Egypt.

Many individuals have contributed to the success of this project. I would like to express my gratitude in particular to Sir Eric Anderson, Former Provost of Eton College (2000–2009), who initiated the Eton-Myers collaborative project, and to the current Provost Lord Waldegrave of North Hill for carrying it forward; Andrew Wynn, Bursar of Eton College, and Professor Stephen Shute, Former Pro-Vice Chancellor of the University of Birmingham, for all their work in this three-party collaboration; Dr Henry Chapman, Director of the Visual Spatial and Technology Centre (VISTA), and his team for the application of cutting-edge technology to the study of the Eton-Myers artefacts; and last but not least Dr Eurydice Georganteli and Dr Martin Bommas for putting together this splendid exhibition and publication.

Sir Dominc Cadbury
Chancellor of the University of Birmingham

Since its foundation in 1440, Eton has been given many treasures by donors who wished to widen the education of our pupils and to ensure the transmission of their gifts to future generations. One of the most spectacular of these bequests is the Myers Collection of Egyptian Antiquities, the history of which is eloquently described by Dr Georganteli in the first chapter of this excellent book. It is therefore a source of great pleasure to Eton that some of the most outstanding items from the collection should be at the centre of the Barber Institute's magnificent new exhibition, *Sacred and Profane*, alongside items from the Institute's own famous collection of coins from the Alexandria of the Roman and Byzantine periods.

The exhibition marks the launch of a partnership between Eton, the University of Birmingham and Johns Hopkins University, the object of which is to make Major Myers's bequest to us more widely available to the public, both digitally and by means of a display at the Barber Institute, while we retain a core at Eton for teaching purposes. It is our firm intention to seek to raise funds to ensure that when the fifteen-year period of this partnership is complete, there will be facilities for the proper permanent display of the collection at Eton; in the meantime Birmingham and Johns Hopkins are helping us to introduce it to a wider public. For that we are most grateful.

Lord Waldegrave of North Hill
Provost of Eton College

Preface

The Barber Institute of Fine Arts and the College of Arts and Law at the University of Birmingham are delighted to support a unique partnership between Eton College and Johns Hopkins University. The project brings the internationally renowned Myers Collection of Egyptian artefacts to a wide audience through an exhibition at the Barber whilst promoting an innovative programme of academic research which is published here.

The academic study of Egyptian artefacts has a distinguished pedigree in Britain. Less well known is the way contemporary scholarship can bring a sophisticated cross-disciplinary approach to the subject. The essays in this book illustrate the important role Birmingham University plays in opening up new avenues of investigation. This reflects the way Egyptology acts as an interface within the Institute of Archaeology and Antiquity between many disciplines and cultures, including classics, ancient history, Byzantine, Ottoman and modern Greek studies, as well as the study of ancient religion and cultural memory. This new approach is epitomized by the innovative 3D imaging produced for this project by the Visual and Spatial Technology Centre (VISTA), one of Europe's leading archaeological visualization laboratories.

The Barber Institute, together with the university's holdings as a whole, provides an engaging context for the display of the Eton Myers collection, reflecting the fascination the British public has long held for Egyptian artefacts. As well as being renowned as an outstanding art gallery, the Barber is home to an extensive collection of Roman and Byzantine Alexandrian coins, rare in Britain. The priceless Coptic, Arabic and other Middle Eastern manuscripts from the Mingana collection provide a further university context for the project.

The sacred and profane as a theme has resonances that have encouraged further collaborations involving scholars of theology, music, comparative literature and West African studies. This wide-ranging exploration has been sponsored by the College of Arts and Law and nurtured by Dr Eurydice Georganteli, Curator of the Coin Collection at the Barber and Lecturer in Numismatics in the College of Arts and Law, and by Dr Martin Bommas, Senior Lecturer in Egyptology in the College. They have shown immense dedication in their work on the exhibition and this book. The latter has been brought together splendidly by Dan Giles. We also extend our particular thanks to Lord Waldegrave of North Hill, Sir Eric Anderson and Sir Dominic Cadbury, for the key roles they played in supporting this project. We are proud to be associated with this exhibition and book and warmly recommend both to anyone interested in the sacred and the profane, however that is understood.

Professor Martin Stringer, Head of College of Arts and Law
Professor Ann Sumner, Director of the Barber Institute of Fine Arts

Introduction

In his groundbreaking book *The Sacred and the Profane* [*Le Sacré et le Profane*] (1956) Mircea Eliade, the historian of religions, observed that the divine things worthy of veneration are separate from everyday life. Visual borders, such as entrances to churches and temples, act both as visual dividers and links between the sacred and the profane. Architecture is not the only medium allowing the sacred to meet the profane however. Objects produced in a profane environment can ritualistically be transformed into *res sacrae*, sacred things, that enable encounters with the divine. These objects are made by men to be recognized by deities, triggering actions impossible to imagine in a strictly profane environment.

Ancient Egypt was saturated by a regulated symbiosis of the profane and the sacred with Pharaohs guaranteeing the prosperity of Egypt in accordance with the will of gods and goddesses. Funerary beliefs, magical rites and even personal religion also embodied the search of the ancient Egyptians for the sacred beyond the public sphere and state intervention. This process is nowadays only identifiable through the surviving material culture such as papyri, coffins or tools and instruments: objects regarded as indispensable for crossing the border between the profane and the sacred.

The Myers collection is one of the most stunning assemblages of ancient Egyptian art worldwide. It was bequeathed to Eton College by Major William Joseph Myers (1858–1899), one of Eton's finest alumni, who collected in Egypt in 1880s. The *Sacred and Profane* research project celebrates this extraordinary bequest and focuses on ancient Egypt's complex relation with the sacred and the profane. Statuettes of mortals and gods, funerary masks, jewellery, pottery and papyri are discussed for the first time in a thematic way alongside holdings from the rich Barber Institute collections.

Special thanks are due to the contributors of the present publication, Dr Michela Luiselli and Dr Michael Sharp. In addition, we would like to thank Andrew Wynn, Bursar of Eton College; Penny Hatfield, Archivist, and Dr Nicholas Reeves, former Curator of the Eton-Myers collection; Dr Roberta Cortopassi and Dr Elsa Rickal of the Département des Antiquités égyptiennes, Musée du Louvre; Professor Stephen Shute, former Pro-Vice Chancellor at the University of Birmingham; Professor Martin Stringer, Head of the College of Arts and Law at the University of Birmingham; Professor Ann Sumner, Director of the Barber Institute of Fine Arts, and Dr Gregory Smith, Senior Curator; Professor Vince Gaffney, Head of Research and Knowledge Transfer, College of Arts and Law at the University of Birmingham; Professor Ken Dowden, Director of the Institute of Archaeology and Antiquity at the University of Birmingham; Jonathan Shea, Curatorial Assistant to the Barber Institute Coin Collection, and Nubar Hampartumian, Honorary Keeper of Coins; Dr Dimiter Angelov, Research

Fellow in Byzantine History at the University of Birmingham; Susan Worrall, Head of Special Collections; Sarah Kilroy, Senior Conservator; and Marie Sviergula, Conservator of the Special Collections, University of Birmingham. Last but not least we are indebted to Graham Norrie of the Institute of Archaeology and Antiquity, University of Birmingham, and Jan Starnes of Oxford Imaging Ltd for their artistic flair in producing excellent photographs.

Eurydice Georganteli and Martin Bommas

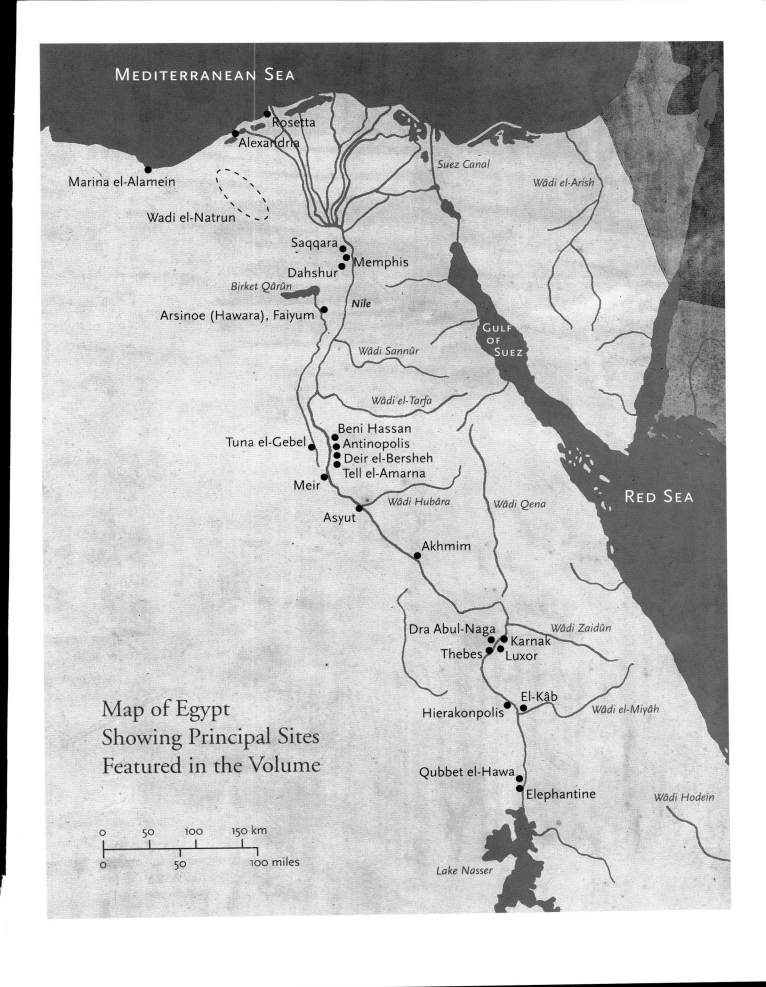

MEDITERRANEAN SEA

Rosetta
Alexandria

Marina el-Alamein

Suez Canal

Wâdi el-Arish

Wadi el-Natrun

Saqqara
Dahshur Memphis

Birket Qârûn

Nile

Arsinoe (Hawara), Faiyum

Wâdi Sannûr

GULF
OF
SUEZ

Wâdi el-Tarfa

Beni Hassan
Tuna el-Gebel Antinopolis
Deir el-Bersheh
Tell el-Amarna
Meir

RED SEA

Wâdi Hubâra *Wâdi Qena*

Asyut

Akhmim

Dra Abul-Naga *Wâdi Zaidûn*
Karnak
Thebes Luxor

El-Kâb
Hierakonpolis *Wâdi el-Miyâh*

Map of Egypt
Showing Principal Sites
Featured in the Volume

Qubbet el-Hawa
Elephantine *Wâdi Hodein*

0	50	100	150 km
0		50	100 miles

Lake Nasser

A Visual Chronology of Ancient Egypt

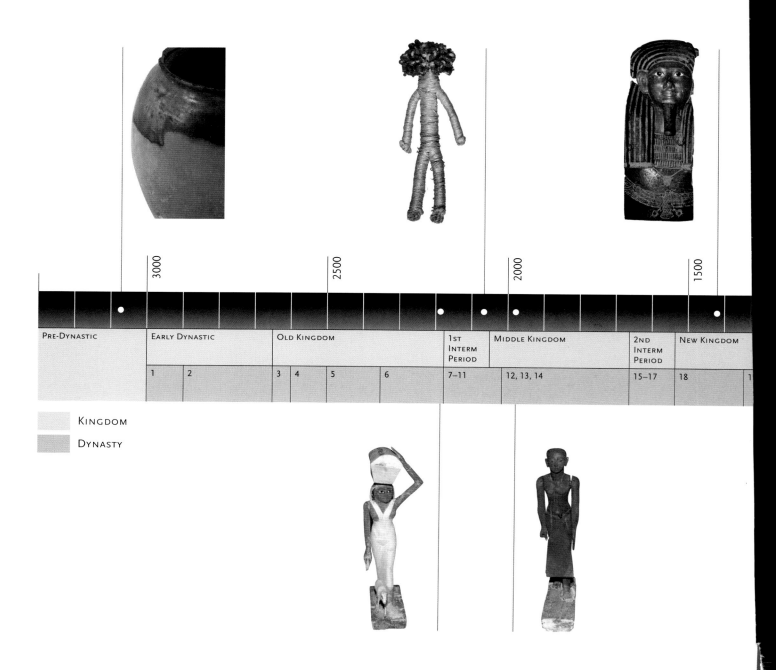

Pre-Dynastic	Early Dynastic		Old Kingdom				1st Interm Period	Middle Kingdom		2nd Interm Period	New Kingdom
	1	2	3	4	5	6	7–11	12, 13, 14		15–17	18

Kingdom
Dynasty

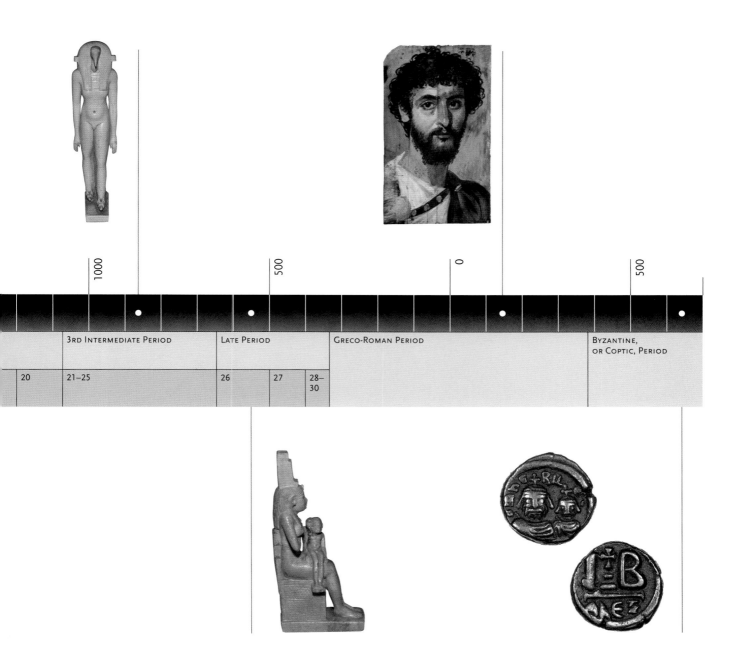

| | 1000 | | 500 | | 0 | | 500 |

	3RD INTERMEDIATE PERIOD		LATE PERIOD		GRECO-ROMAN PERIOD		BYZANTINE, or COPTIC, PERIOD
20	21–25		26	27	28–30		

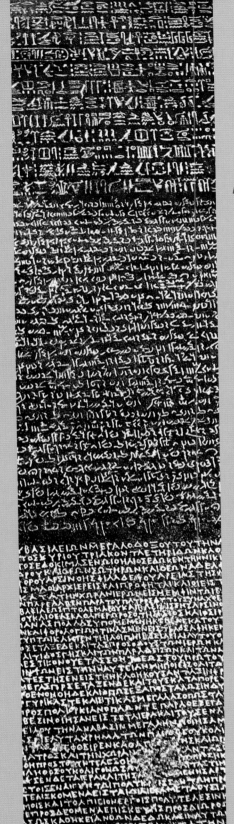

1

The Myers Eton College Collection of Egyptian Antiquities: Travel, Archaeology and Collecting Attitudes in Nineteenth-century Egypt

Eurydice Georganteli

Major W. J. Myers and the Myers Eton College Collection of Egyptian Antiquities

The Myers Eton College Collection of Egyptian Antiquities is not only among the most perfect assemblages of ancient Egyptian decorative art worldwide but also a window into the distant world of travellers, collectors and pioneer archaeologists in nineteenth-century Egypt and the Middle East. In 1899 Eton College mourned one of its finest alumni, killed in action at the Battle of Ladysmith in the first month of the Second Boer War, at the age of just forty-one. Major William Joseph Myers (fig. 2) had retired from the British Army in 1894. Dr Edmund Warre, Head Master of Eton, invited him to return to the College in

Below
1. The Long Walk, King's College of Our Lady of Eton, besides Windsor, in the 1890s. By kind permission of the Provost and Fellows of Eton College.

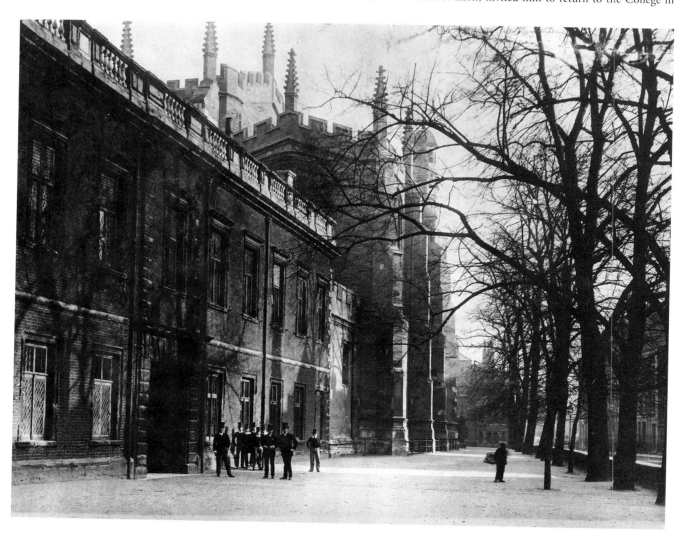

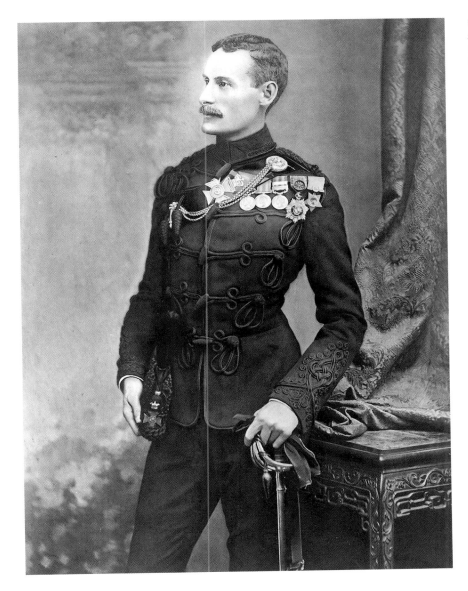

1898 as Adjutant to the Eton College Rifle Volunteers (fig. 3). The sense of loyalty and devotion that underlined all his actions and relationships, however, including his lifelong one with Eton College, led him to rejoin the King's Royal Rifle Corps as war in South Africa approached. As commander of the Rifle Depot, the regimental barracks in Winchester, he could have stayed away from active service, but instead he volunteered to put himself forward. On his death Eton was to become the beneficiary of Myers's collection of Egyptian antiquities, his library and diaries.[1]

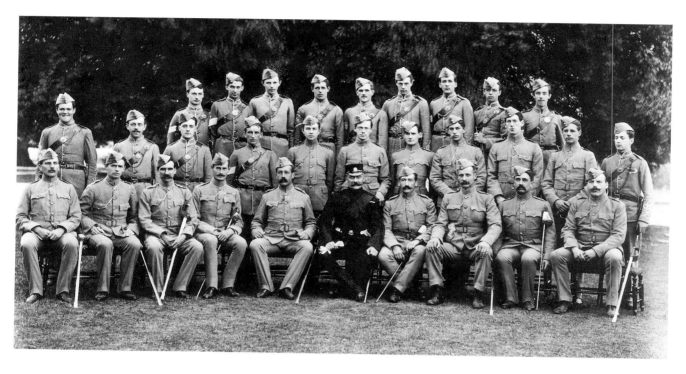

Above

3. Formal group photograph of the Eton College Rifle Volunteers in 1899. Officers and Sergeants flank their Adjutant, Major W. J. Myers (seated in the front row, fourth from left). By kind permission of the Provost and Fellows of Eton College.

The years that Myers spent at Eton (1871–5) were truly formative, as he cultivated his inquisitive mind, love of history and the arts, mental and physical courage and humour in adverse situations. After graduating from Sandhurst, Myers obtained a commission in the 16th Foot in 1878 and transferred to the 60th Rifles the following year. In the course of sixteen years his military duties took him on a whirlwind trip around the world. Egypt, Gibraltar, Cyprus, India, Tibet, Burma, Russia, Central Asia, Panama and the West Indies are some of the places Myers visited and where he was posted.

Egypt was already under British occupation when Myers landed in Alexandria in 1882. His first impressions of the city, which had suffered heavy bombardment and a land assault, were not great. Cairo was a different story. In the Europeanized section of the city Myers had access to the usual pastimes and comforts of a well-off and educated expatriate. He was a meticulous diarist, detailing his experience during his travels around the world in some 34 volumes. Diary numbers 3 (1882), 4 (1884), 5 (1884), 6 (1885), 6a (1885), 8, 9 and 10 have references to Egypt and record an impressive range of social activities in addition to his military duties. River trips, donkey races, polo, opera and theatre outings, fine dining, Sunday services, riding to the Pyramids and bazaars, collecting photos and carpets, and visiting Coptic churches were all part of young Myers's exposure to Egypt. He was clearly a young man who was always inquisitive and eager to sample the delights and cultural treasures of the areas where he served.

It was not until 1884 that entries in his diary detail his exploration of Egypt's archaeological treasures. Egypt is painted in Myers's account as a dream playground for budding archaeologists, full of exciting new discoveries laying about. In the morning of 2nd February 1884 Myers and his fellow passengers, who were aboard a boat sailing up the Nile, mounted donkeys and rode off to a nearby town.

> The town is very picturesque from a little distance as also the entrance gate of the
> town shaded by some large trees. Went into the town ... to see the cases and tombs
> where the sacred wolves were also buried. The catacombs are of great extent and
> there were a good many remains of mummies laying about (diary 5).

The picture Myers paints is so alien to that of twenty-first century archaeological sites, with restrictions, rules and regulations neatly displayed at the entrance. On 4 February 1884 Myers went up the Nile and paid a twenty-minute visit to Luxor 'during which there were swarms of antique vendors crowded round the steamer'. After dinner one evening all the passengers left the steamer and, carrying lanterns, walked into a town to look at the uncovered remains of a temple:

> It [the temple] lies in the centre of the town and is approached
> through a gate and alley belonging to a private individual. There
> is only the entrance hall visible, the rest is covered and surrounded
> by neighbouring houses. The columns are magnificent, each
> capital very different and representing lotus flowers.

Aswan provided another important sight for Myers. His walks brought him to a small temple and the granite quarries at the outskirts of the city, which, as he observed, must have accounted for the entire granite production in Lower Egypt. He looked at the marks in the rock and a gigantic unfinished obelisk still set in the granite beds, and made some remarks regarding the ancient workmanship. On 6 February he took the ferry to Elephantine Island and identified the ruins from Amelia Edwards's recently published book *One Thousand Miles up the Nile* (London, 1877). Further along his journey Myers saw the columns of Abu Simbel from a distance and marvelled at the great temple, which after the Pyramids and Karnak was said to be the prettiest monument in Egypt. His exploration of Karnak, on the other hand, left him disappointed and feeling that the site was 'not much more than a tremendous heap of ruins' (fig. 4). The implementation of an extensive restoration programme at Karnak a century later has since allowed visitors to appreciate the monumentality and symbolism of its topography.

The first impression one has from reading Myers's diaries is that he was keen on recording minutiae, such as his visits to the dentist on 2 and 3 December 1884, 'to have a tooth stuffed'

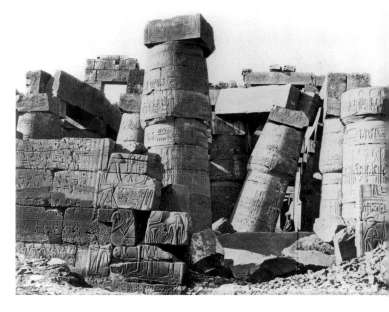

Above
4. The southern doorway to the hypostyle hall, of the temple precinct of Amun at Karnak. Photo by Félix Bonfils, c. 1880. Collection of the Archive of the Griffith Institute, Oxford, Gr. Inst. 6286.

(diary 5: 1884). When reading his account of his trip up the Nile (also in diary 5), however, the picture one gets is quite different. Through his pencilled scribbles Myers comes to life as an intrepid traveller, hooked on the charm exuded by archaeology and Egypt's rich cultural kaleidoscope. His notes still hold the power to transport readers to the world of nineteenth-century archaeologists and adventurers.

Myers compiled a catalogue of the nucleus of his Egyptian antiquities collection in Cairo on 11 November 1887. Although brief and by no means descriptive, it provides an interesting insight into archaeology and collecting attitudes in nineteenth-century Egypt. From references that appear in some of his catalogue entries and diaries, it is clear that as a collector Myers had the assistance and support of Émile Charles Albert Brugsch, deputy curator of the Boulaq Museum in Cairo and a key figure in archaeological work conducted in Egypt during the last quarter of the nineteenth century. Brugsch had come to Egypt in 1870 to join his elder brother, Heinrich Ferdinand Karl Brugsch, professor of Egyptology at the University of Göttingen and director of the School of Egyptology in Cairo, and he initially assisted his brother in the operation of the School of Egyptology until its closure nine years later. He was then appointed assistant curator at the Boulaq Museum, a position he held until his retirement in 1914.

Myers's 211 entries (207 numbered; 4 unnumbered at the end of the catalogue) follow no particular thematic or chronological order. This indicates either an ad hoc registration of the objects, whenever they came into his possession, or an eclectic attitude towards his holdings. I am inclined to argue for the latter, especially when taking into account the existence of a few pages that contain the first draft of the entire catalogue written in pencil, apparently by Myers. The entries occasionally mention provenance (e.g. Lower Thebes) or the broad chronology of the object (e.g. no. 61: Thebes; no. 70: from tomb of Kings, Deir el Bahri). Myers does not seem to have been particularly interested in recording the exact location of the finds, or the conditions under which they were discovered, something his sister G.H. Vandeleur mentioned in her 28 May 1934 accompanying letter when she presented the catalogue to E.L. Vaughan, former Master at Eton College: 'He [Myers] refers to trips up the Nile, visits to tombs and temples, but does not explain how he made his collection'

In catalogue entry no. 113 Myers mentions a drinking cup of rare colour and form found in a 13th Dynasty (1783–1649 BC) tomb in Thebes, with the evocative inscription 'the giver of eternal life, the good god, master of the two lands' (fig. 5). Entry no. 116 records another piece of pottery from a tomb, which Myers explains is one of a group of 4 he possessed. 'Brugsch tells me he only found 28' states Myers, and this single sentence reveals the facilities Émile Brugsch had as a high official in Egypt's archaeological service to record, collect and dispose of things at his discretion. The other 24 vases were unsurprisingly, in the possession of important individuals, such the Sultan, Émile Brugsch, and of the two leading institutions of their time in the archaeology of Egypt and the Middle East, the British Museum and the Louvre.

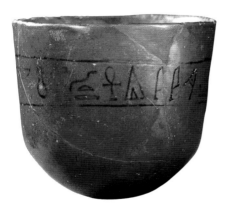

Above

5. Blue bowl with inscription, 13th Dynasty, *Myers Collection at Eton College, ECM 113.*

Travel, Archaeology and Collections in Nineteenth-Century Egypt[2]

Myers was not the only one discovering ancient Egypt. The land of the Israelites' exile in the Old Testament was familiar to the ancient Greek world through networks of warfare, trade and religion. It is therefore not surprising that four important ancient Greek texts discuss Egypt. In Homer's epic *Odyssey* a passage describes an island rising from the waters off the shores of Egypt.[3] Its name was Pharos, and it was here that Alexander the Great founded Alexandria. Herodotos (*c.* 484–420 BC) dedicated the second book of his nine-volume *Histories* to Egypt, its society, customs and monuments.[4] Four centuries later Diodoros Sikelos described the history and culture of the country in the first book of his forty-volume *Bibliotheca historica* (Historical Library), while the historian, geographer and philosopher Strabo (63/64 BC–*c.* AD 24) made Egypt an important part of the final part of his seventeen-volume *Geographica*.[5]

In the autumn of 332 BC Alexander the Great entered Egypt, then dominated by the Persians. He was greeted as a liberator by the locals and spent six months in the country reorganizing Egypt's administration, studying Egyptian laws and customs, and visiting important religious and royal sites. His most lasting legacy was undoubtedly the foundation in 331 BC of Alexandria, a city that was to become a major trade and cultural hub in the Mediterranean (fig. 6). In 321 BC Alexander's body, still en route to its resting place two years after the king's early death, was diverted from Syria to Memphis where it was buried by Ptolemy, one of Alexander's generals and subsequently Ptolemy I, king of Egypt. The body was then moved to Alexandria, first to a tomb and later to a royal mausoleum together with members of the Ptolemaic dynasty. Alexander's sarcophagus and body acquired a cult status and were to remain a principal destination for travellers, including several Roman emperors. Sometime in the late fourth century AD the monument and sarcophagus of Alexander disappeared. This did not pass unnoticed by John Chrysostom, who asked in one of his *Homilies*, 'For, tell me, where is the tomb of Alexander? Show it me and tell me the day on which he died …'[6] The question was hardly rhetorical. It acknowledges the new Christian topography of Alexandria and its surrounding area, clearly devoid of Alexander's tomb, but with the tomb of St Mark the Evangelist and the shrine of St Menas functioning as major new destinations for pilgrims travelling to Byzantine Egypt from as far as Anglo-Saxon Britain.

From the time of Saladin (1137–93), the Ayyubid ruler of Egypt and Syria who fought the crusaders,[7] and the capture of the port of Damietta (Domyat) in 1249 by King Louis IX

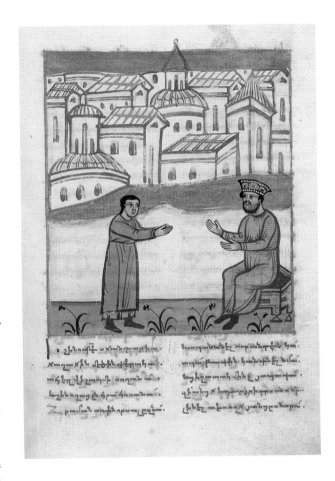

Above

6. The foundation of the city of Alexandria by Alexander the Great. Illumination from an Armenian version of pseudo-Callisthenes's Alexander Romance. Turkey or Iran, 17th century. *Bibliothèque nationale de France, Département des manuscrits orientaux, Armenien 291, fol. 38.*

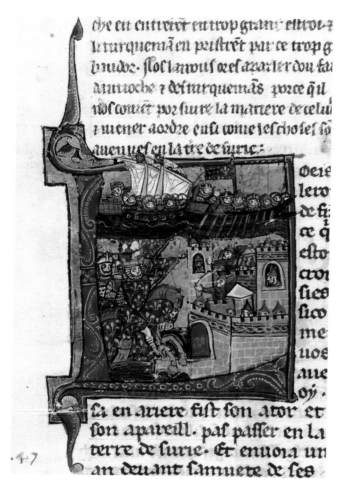

7. The capture of Damietta in Egypt by Louis IX of France. Illumination from William of Tyre's, *Historia et continuation*, created at Acre in the late 13th century. *Bibliothèque nationale de France, Département des manuscrits occidentaux, Français 2628, fol. 328v.*

of France (ruled 1226–70) during the Seventh Crusade encounters between Egypt and Western Europe resumed in the context of warfare (fig. 7). Although the crusaders eventually lost Egypt to the Mamluks, trade links with the area increased, especially after 1536, when commercial privileges were granted by Süleyman the Magnificent (*reg* 1520–66) to Francis I of France (*reg* 1515–47). The privileges, known as Capitulations, were devised in different chapters (*capitula*) and were renewable upon review. They offered France trading posts in Ottoman Egypt from where their agents and merchants could operate. Western products such as finished cotton, silks and metalwork were traded for Egyptian raw cotton, rice, ivory, ostrich feathers and coffee, the new product that was taking Europe by storm. Despite some initial reservations other European nations soon followed France's example, and it was not long before wealthy travellers started to explore Egypt's Christian shrines, looking for precious relics such as Philippe de Milly had obtained from the monastery of St Catherine on Sinai in the 1160s. The travellers' accounts are a mixture of the imaginary, the vague and the accurate. The famous Sphinx at Giza was described by the sixteenth-century traveller Pierre Belon du Mans as a carved monster looking like a Virgin at the front and like a lion in the rear: the same monument was presented by Belon's contemporary, André Thévet, a monk from Angoulême, as a round curly head in a field of flowers.[8] Similar flights of imagination did not prevent sphinxes from becoming fashionable and decorative elements in sixteenth-century European gardens, villas and tombs. Meanwhile a new healing drug of a peculiarly Egyptian flavour became all the rage in European circles. Prescribed by Arab physicians since the second half of the eighth century,[9] the drug was *mummia*, a dark powder or paste containing ground-up mummies, which apothecaries supplied to heal respiratory and gastric problems, ease period pains and regulate blood pressure. Patients, including royalty, swore by it. The famous Renaissance surgeon Ambroise Paré was so outraged by this practice that he devised an entire discourse against *mummia*, warning about the disastrous effects of the drug.[10]

The influx of anything associated with Egypt prompted the emergence in Europe of the first Egyptian cabinets of curiosities[11] and the beginnings of a more systematized study of ancient Egyptian art. The renowned Jesuit scholar Athanasius Kircher (1602–80), professor of mathematics, physics and oriental languages at Rome's Collegio Romano, produced seven books on the study of Egyptian artefacts, ranging from obelisks and Coptic manuscripts to ancient water clocks (fig. 8).[12] His study, in particular, of two ancient obelisks in Rome that

formerly adorned the Circus Maximus and the entrance to the temple of Isis, and which were now incorporated by Gian Lorenzo Bernini in his designs for the Piazza Navona[13] and the piazza in front of the church of Santa Maria sopra Minerva, tells an interesting story of the reuse of Egyptian monumental sculpture in a seventeenth-century urban setting. Bernini's choice was no accident. Across Renaissance Europe, Egypt and its yet undeciphered hieroglyphic script were viewed as doorways to great wisdom, and Egyptian themes slipped easily into a wide range of art. Jean-François Regnard's choral comedy *The Mummies of Egypt (Les Momies d'Egypte)*, performed in 1696 at the Théâtre de Bourgogne in Paris, features an interesting combination of Cleopatra, Osiris, Arlequin and Colombine.[14] In 1724 George Frideric Handel presented in London the much acclaimed opera *Julius Caesar in Egypt (Giulio Cesare in Egitto)*. Cleopatra in this case, unlike Jean-François Regnard's caricature, echoes the complex character of the last Hellenistic queen of Egypt.[15] For Freemasons ancient Egypt meant a lot more. They considered Imhotep, the creator of the Step Pyramid in Saqqara, as the Great Architect of the Universe,[16] and their philosophical line and symbolism are evident in the libretto of Mozart's opera *The Magic Flute (Die Zauberflöte)* (1791).[17]

The love of all things Egyptian continued well into the eighteenth century. Ancient artefacts and Egyptian-styled objects were much sought after by European aristocrats, churchmen, royalty and revolutionaries alike. In the early eighteenth century four magnificent statues of *Ptolemy II*, *Arsinoe II*, *Tiye* and a Roman copy of *Arsinoe* were discovered in Rome at the Villa Verospi, the site of the Gardens of Sallust. Pope Clemens XI, who was particularly interested in archaeology, had the first two installed in the Museo Capitolino and the others restored and displayed in the Consiglio Comunale.[18] But it was really the German art historian and archaeologist Johann Joachim Winckelmann who, in his ground-breaking study *History of the Art of Antiquity (Geschichte der Kunst des Alterthums)* (1764), analysed Egyptian monuments and chronology and corrected previous misattributions. Winckelmann deemed Egyptian art to be of lower quality than that of ancient Greece, and thought that the quality was directly related to the physical landscape in which it was created. In response to Winckelmann's thesis, Giovanni Battista Piranesi defended the monumentality and durability of Egyptian architecture in his book *Diverse maniere d'adornare i cammini ed ogni altra parte degli edifizj desunte dall'architettura egizia, etrusca, e greca, con un ragionamento apologetico in difesa dell'architettura egizia e toscana* (Rome, 1769).

In 1798 encounters between Egypt and Western Europe took a different turn, when the French general Napoleon Bonaparte invaded Egypt.[19] His military expedition claimed to be

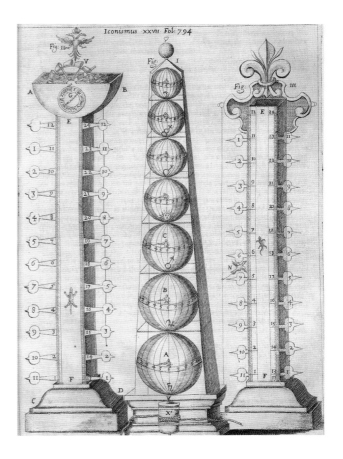

Above

8. Egyptian water clock. Illustration from Athanasius Kircher, *Ars magna lucis et umbrae* (Rome, 1646).

on a civilizing mission: in addition to 54,000 soldiers, there was a staggering total of 167 learned civilians, including mathematicians, astronomers, civil engineers, geographers, architects, sculptors, interpreters, archaeologists and painters to document the French presence in the area.[20] Despite the defeat of the French fleet by the Royal Navy under Nelson at the Battle of the Nile in August 1798, the French were not dissuaded from creating the Institut d'Égypte later that month, intended to provide technical advice to the French military and administration of Egypt, to open up Egypt and show its wonders to Europe, and to bring the arts of Europe to a 'semi-barbarian' and 'semi-civilized' country. The Institut's initiatives opened the way for the first systematic exploration and description of Egyptian sites, published in the monumental series *Description de l'Egypte* (1809–28).[21] The Rosetta Stone, a stele bearing a decree by Ptolemy V (*reg* 204–181 BC), king of Egypt, carved in 196 BC in Greek, hieroglyphs and demotic Egyptian (fig. 9), was discovered by the French military engineer Pierre-François Bouchard in 1799 during building work at el-Rashid (Rosetta). The stele was eventually taken to London, where it was presented first to the Society of Antiquaries and later to the British Museum. The deciphering of the hieroglyphs and demotic Egyptian script by Jean-François Champollion, Professor of Egyptology at the Collège de France, and the English polymath Thomas Young offered a major breakthrough in our understanding of the ancient Egyptian language and its literature from 1822. In 1828–9 a Franco-Tuscan expedition led by Champollion and Ippolito Rosellini, Professor of Oriental languages at Pisa University, sailed upstream along the Nile.[22] A later Prussian expedition in 1842–5, led by the archaeologist and linguist Karl Richard Lepsius, studied numerous sites in Egypt and the Sudan, before concluding its survey in the Nile Delta. Lepsius became the first Professor of Egyptology in Berlin in 1846, and his magisterial thirteen-volume publication *Denkmäler aus Ägypten und Äthiopien* (Berlin, 1849) is still a standard work of reference (figs. 10 and 11). In 1886 the Institut d'Égypte was reborn and started the publication of the *Mémoires* series that was to become the model in Europe and the USA for similar scholarly publications related to Egypt. The surge in archaeological surveys and scholarly publications on Egypt further whetted the appetite of amateur archaeologists, collectors and adventurers for ancient artefacts. The lack of even the most basic legislation in Egypt to protect its cultural heritage meant that large numbers of artefacts left the country, not only carried by treasure-hunters but in certain cases donated by the Egyptian authorities to foreign heads of states and diplomats as tokens of friendship or as part of diplomatic exchange. The obelisk of Ramses II, 23 metres high and weighing 230 tonnes, which once adorned the entrance to the temple at Luxor, arrived in Paris in 1834 as a gift from Mehmet Ali, Viceroy of Egypt. The logistics of both its removal from Luxor and its erection in the Place de la Concorde attracted considerable attention (fig. 12).[23]

The appointment of Auguste Mariette (1821–81) by Said Pasha, Viceroy of Egypt, as the first director of antiquities in Egypt changed all this in 1858.[24] One of Mariette's primary concerns was to stop the export of antiquities, an issue with which Mariette was only too familiar. As a junior employee of the Musée du Louvre he was sent to Egypt in 1850 in search

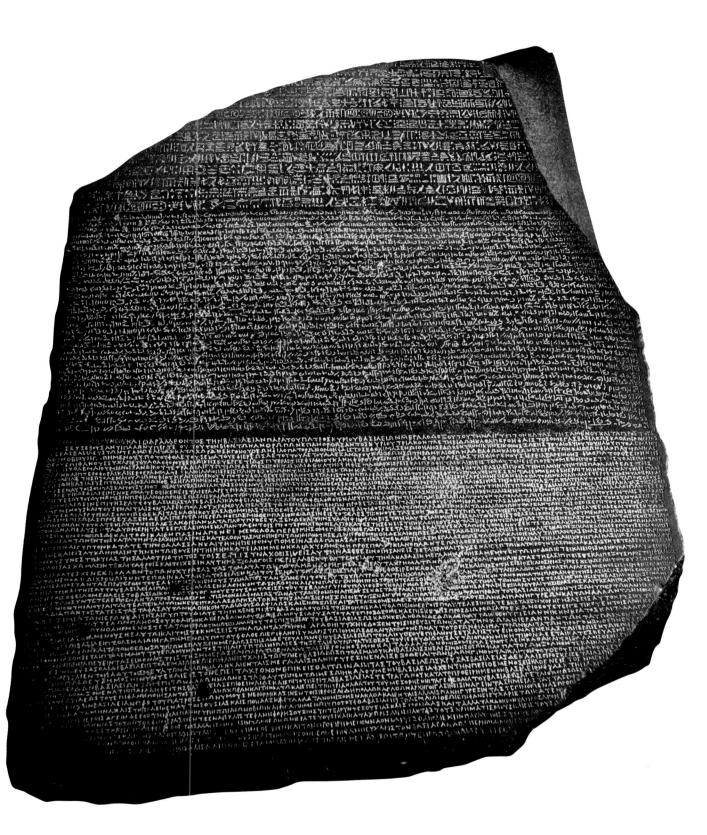

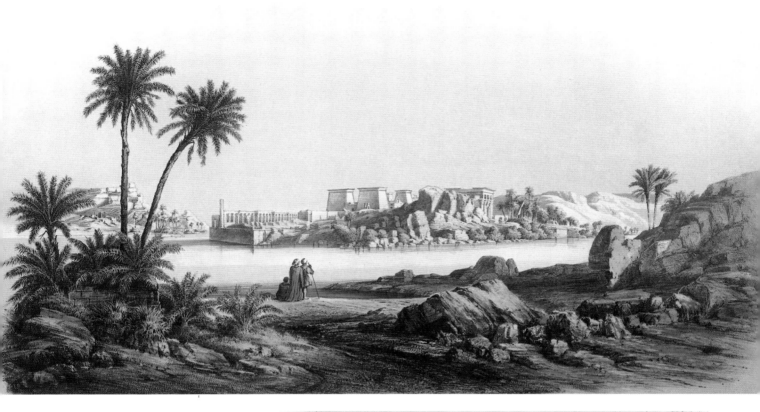

Above
10. Philae. Engraving from Karl Richard
Lepsius, *Denkmäler aus Ägypten und Äthiopien*
(Berlin, 1849), I, pl. 105.

Right
11. Temple of Abu Simbel. Engraving from
Karl Richard Lepsius, *Denkmäler aus Ägypten
und Äthiopien* (Berlin, 1849), I, pl. 110.

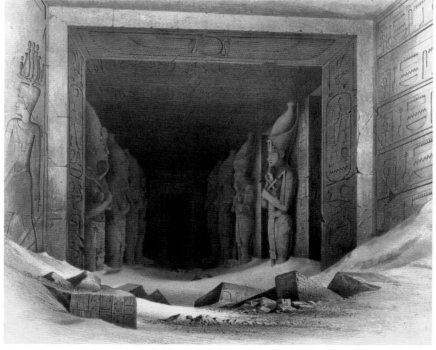

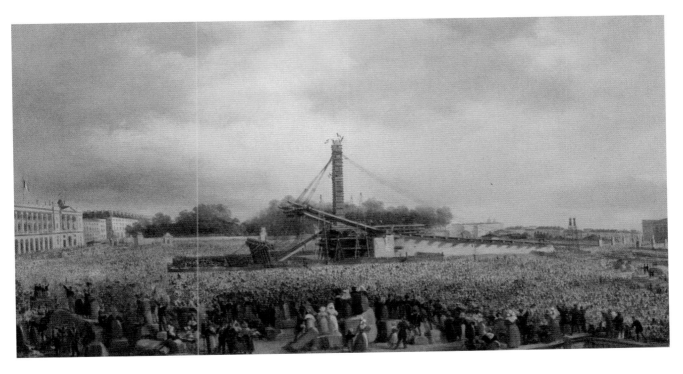

Above
12. François Dubois (1790–1871): *Erection of the Luxor Obelisk on the place de la Concorde, 25 October 1836*, oil on canvas, 1836.
Musée Carnavalet, Paris.

of Coptic manuscripts. In the course of the 1850s he shipped to the Louvre no fewer than 230 crates packed with ancient treasures. His actions were not viewed as anything extraordinary: ancient artefacts were regularly purchased by important European and American museums and collectors, which were considered the only worthy custodians of Egypt's rich heritage. In his new role Mariette went further than banning exports. In 1863 the Boulaq Archaeological Museum near Cairo was opened in order to house part of the vast number of objects Mariette had excavated, and to display Egypt's first national collection in elegant surroundings (figs. 13 and 14). The museum soon became a major tourist attraction. One of its most famous visitors, the author Amelia Edwards, wrote about the museum in her customary, succinct way:

> It is difficult to say but a few inadequate words of a place about which an
> instructive volume might be written; yet to pass the Boulaq Museum in silence
> is impossible. This famous collection is due, in the first instance, to the liberality
> of the late Khedive and the labours of Mariette. With the exception of Mehmet
> Ali, who excavated the Temple of Denderah, no previous Viceroy of Egypt had
> ever interested himself in the archæology of the country. Those who cared for
> such rubbish as encumbered the soil or lay hidden beneath the sands of the desert,
> were free to take it; and no favour was more frequently asked, or more readily
> granted, than permission to dig for 'anteekahs'. Hence the Egyptian wealth of our

museums. Hence the numerous private collections dispersed throughout Europe. Ismail Pasha [Viceroy from 1863], however, put an end to that wholesale pillage; and, for the first time since ever 'mummy was sold for balsam', or for bric-à-brac, it became illegal to export antiquities. Thus, for the first time, Egypt began to possess a national collection.[25]

The severe floods that damaged the Boulaq Museum in 1878 made it necessary to move the archaeological collections to new premises at Giza. In 1899 Gaston Maspero, during his second spell as Director of Antiquities, arranged for the collections to be moved once more from Giza to Midan El Tahrir in central Cairo. Opened in 1902, the new museum was designed by the French architect Marcel Dourgnon, in a Neoclassical style, and this is where Egypt's treasures are still housed.

Highlights of this spectacular archaeological collection were shown at the international exhibitions in London (1862) and Paris (1867).[26] The exhibits in the Egyptian park at the Paris Exposition Universelle made such an impression on Empress Eugenie that she asked Ishmail Pasha to give her the entire Egyptian collection. Her request was, as expected, turned down by Mariette, who subsequently allowed only small objects and facsimiles to leave the Boulaq Museum for the international exhibitions in Vienna (1873), Philadelphia (1876) and

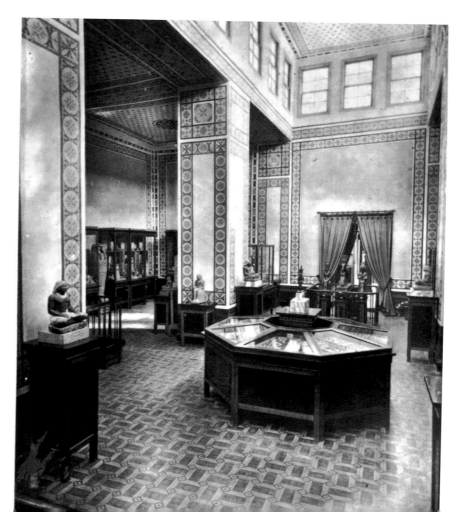

Left
13. Central hall in the Boulaq Museum. Photograph by Émile Béchard and Hippolyte Délié from Auguste Mariette, *L'Album du Musée de Boulaq* (Cairo, 1872).

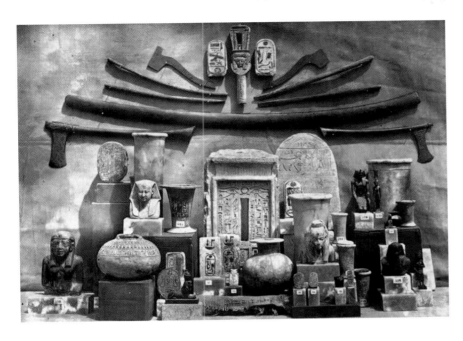

Above
14. Exhibition area in the Boulaq Museum.
Photograph Auguste Mariette, *L'Album du Musée de Boulaq* (Cairo, 1872).

Paris (1878). The first international exhibitions prepared the ground for the phenomenal success the opera *Aida* had when it was premiered in Cairo (1871) and Milan (1872). The opera was composed by Giuseppe Verdi on a libretto which was based on a short scenario written by Auguste Mariette. For the first time in the history of an Egyptian-themed opera the costumes, designed by Mariette, looked suitably Egyptian (fig. 15).

Gaston Maspero, who succeeded Mariette as Director in 1881, was well liked by collectors and directors of foreign museums for his relaxed approach to the export of antiquities.[27] Rather than halting all exports, Maspero allowed objects he did not want for the museum to enter collections in Egypt and abroad. His assistant, Émile Brugsch, actively advised collectors, such as Myers, on their purchases. Those were busy years for Egypt's antiquities market, especially after the introduction of the first organized tours of Egypt by Thomas Cook in the 1860s (figs. 16 and 17). Great demand for the unique and unusual inevitably created a market for fakes: Amelia Edwards recalls with amusement how the genuinely antique pieces presented to her for sale in the 1870s turned out to be more British than expected:.

> It was at Esneh, by the way, that that hitherto undiscovered curiosity, an ancient Egyptian coin, was offered to me for sale. The finder was digging for nitre, and turned it up at an immense depth below the mounds on the outskirts of the town. He volunteered to show the precise spot, and told his artless tale with childlike simplicity. Unfortunately, however, for the authenticity of this remarkable relic, it bore, together with the familiar profile of George IV, a superscription of its

Below
15. Radamès, captain in the Egyptian army, and the Pharaoh of Egypt. Sketches for the opera *Aida* by Auguste Mariette.

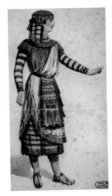
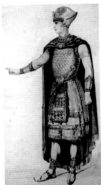

modest value, which was precisely one farthing. On another occasion, when we were making our long stay at Luxor, a coloured glass button of honest Birmingham make was brought to the boat by a fellâh who swore that he had himself found it upon a mummy in the Tombs of the Queens at Kûrnet Murraee. The same man came to my tent one day when I was sketching, bringing with him a string of more than doubtful scarabs – all veritable 'anteekahs', of course, and all backed up with undeniable pedigrees.[28]

Interestingly enough, the seller of the Birmingham glass button claimed that he found it on a mummy, and it seems that he was not the only one disturbing the centuries-long sleep of mummies. Throughout the nineteenth century there was nothing sacred about the way that ancient mummified bodies, discovered across Egypt, were treated by both Egyptians and foreigners. If the *mummia* drug was a sixteenth-century craze in Europe, buying mummies as souvenirs and throwing mummy unwrapping parties became de rigueur among wealthy Europeans and Americans. Egyptians engaged in excavating and selling their distant ancestors to foreigners saw nothing wrong in the act. For some buyers of mummies or mummy parts their purchases represented collectable pieces of Egypt's rich history and prized curiosity objects. The discerning buyer of the 3,000-year-old foot of Princess Hermonthis in Théophile Gautier's short story 'The Mummy's Foot' discovers the ancient limb among antiques in a Parisian curiosity shop, and intends to use it as paperweight.[29] For others, possessing and unwrapping mummies was the closest they could get to the challenges a nineteenth-century archaeologist faced in unearthing, removing layer after layer and decoding the remains of Egypt's distant past. The deciphering of the Rosetta Stone, archaeological publications and surveys, travelogues by Amelia Edwards, François-René de Chateaubriand and Alphonse de Lamartine, and depictions of scenes from nineteenth-century Egypt by Orientalist painter-travellers fuelled the public fascination.[30] Lectures on Egypt offered by anatomy and archaeology professors in university halls, hospitals and historical societies were often

Above
16. Cover of the Thomas Cook travel brochure for the 1898/99 season. (The Thomas Cook Archives).

followed by the unwrapping of mummies. The events proved very popular, and in many ways they replaced the public dissections practised in previous centuries. Théophile Gautier's 'The Unwrapping of a Mummy' offers a vivid account of one such procedure, which took place in the Anthropological Museum of Paris during the 1867 Exposition Universelle.[31] The unwrapping of mummies added that all-important feeling of excitement at private parties, and invitation cards such as 'Lord Londesborough at Home … A Mummy from Thebes to be unrolled at half-past Two' (see fig. 32) were highly anticipated in fashionable London circles.

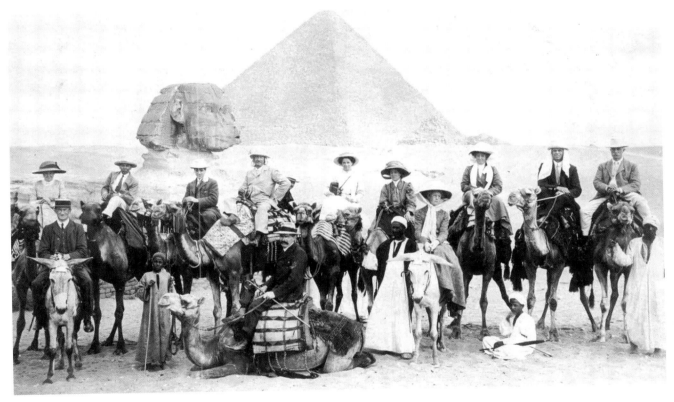

Above
17. Group of tourists from a Thomas Cook tour of Egypt, c.1905. (The Thomas Cook Archives).

The period between 1881 and 1914 were the golden years for Egyptology. Britain, France, Italy, Prussia and the USA were just a few of the countries that invested in resources and specialist expertise for systematic excavations and the recording of sites, monuments and portable antiquities from Egypt. Among the learned bodies that have since been contributing to the study of ancient Egypt the Egypt Exploration Society holds a central position.[32] Founded in 1882 by the author Amelia Edwards and Reginald Stuart Poole, Keeper of the Department of Coins and Medals at the British Museum, the Egypt Exploration Fund, as it was originally known, became synonymous with some of the most groundbreaking discoveries and publications on ancient Egypt. The discovery and publication of texts on Greco-Roman

papyri by Bernard Grenfell and Arthur Hunt is a good example of the work achieved by the Society.[33] Grenfell first visited Egypt in 1893–4 to work at Koptos with Flinders Petrie, who held the first chair of Egyptology in Britain and excavated the important sites of Naukratis, Tanis, Abydos and el-Amarna. The first papyrological publications were of texts purchased by Petrie and Grenfell. Subsequent finds by Grenfell and Hunt are responsible for the Egypt Exploration Society's rich collection of about 500,000 papyri fragments, including Christian writings and masterpieces of ancient Greek literature. Grenfell and Hunt chose to dig at Oxyrhynchus because of its reputation in late antiquity as a Christian centre. Their work at the Roman cemetery of Rubayyat (ancient Philadelphia) in the Faiyum area during the winter of 1900–01 brought them face to face not only with more papyri but also with the predecessors of early Christian pictorial art, the famous Egyptian funerary portraits of the 1st–3rd centuries AD.

Archaeological discoveries in Egypt culminated in 1922 when Howard Carter and his sponsor, Lord Carnarvon, came across the magnificent tomb of Tutankhamun and its treasures in the Valley of the Kings.[34] Once again ancient Egypt became relevant to fashion and influenced artistic taste in Europe and America. Photographs and exhibitions of ancient Egyptian art made it possible to admire the delicacy and intricacy of funerary finds connected with the distant kings and queens of ancient Egypt. If influence from ancient Egypt seems indirect and subtle in Art Nouveau, in Art Deco it is visible in all its manifestations. Hieroglyphs, scarabs and lotus flowers became common motifs on fabrics, accessories, jewellery and graphic design. Egyptian-styled façades graced cinemas, and the monumentality, geometry and symbolism of ancient Egyptian architecture influenced the design of prominent urban landmarks created on both sides of the Atlantic. The RCA Building at the Rockefeller Center and the Daily News Building, both in New York, the Senate House in London, and the Empress Theatre in Montreal are just some examples of Egypt's impact on the Art Deco movement.[35]

Egyptian antiquities are now spread across the world. Major collections in leading European and American museums and university collections have been put together by individuals, such as Major W. J. Myers at Eton College and the art collector Antonios Benakis in Athens,[36] or as part of the acquisition policy and archaeological work of museums and universities in the nineteenth century and the early twentieth. Since 1972 the UNESCO World Heritage Convention on the protection of cultural heritage has dramatically decreased the traffic in Egyptian antiquities and has boosted archaeological work in Egypt and the development, preservation and presentation of ancient Egyptian sites and artefacts. This Egypt might not be the land of adventure Myers encountered in the 1880s, but it remains an inexhaustible source of archaeological, historical and cultural wealth. This is the wealth we would like to preserve, study and present at the University of Birmingham in partnership with Eton College and Johns Hopkins University, and the generosity of Major W. J. Myers has made this possible.

Endnotes

1 On Major W. J. Myers and his legacy, see his obituary 'In Memoriam. William Joseph Myers, born August 4, 1858; died October 30, 1899', *Eton College Chronicle*, no. 863 (December 1899), pp. 761–4; S. Spurr, 'Major W. J. Myers, O.E.: Soldier and Collector', *Egyptian Art at Eton College: Selections from the Myers Museum*, exh. cat., Metropolitan Museum of Art, New York, and Eton College (New York, 1999), pp. 1–3. Myers's unpublished diaries, photographs, the catalogue describing the nucleus of his collection of Egyptian antiquities and the accompanying letter that his sister wrote to the Master of Eton College in 1934 are key to our understanding of this remarkable man. I was able to research this material and transcribe parts of Myers's diaries in November 2009. My gratitude goes to Mrs Penny Hatfield, Archivist at Eton College, for providing access to this material, and to all members of staff of the College Library for their kind assistance and warm hospitality.

2 This chapter could not have been written without the superb resources and collegial atmosphere of the Département des Antiquités égyptiennes, Musée du Louvre. I am indebted in particular to Dr Roberta Cortopassi, curator, Cécile Jail, documentaliste (section copte) and Dr Elsa Rickal, documentaliste scientifique, for their assistance during my work at the Louvre in November 2009. My thanks also to Colin Timms, Barber Professor of Music at the University of Birmingham, for helping me understand Egypt as a music theme and for all the inspiring discussions on art and music we have had in the Barber Institute over the years.

3 *The Odyssey of Homer*. Translated and with an introduction by R. Lattimore (New York and London, 1967), book IV, 354–5.

4 *Herodotos*, books I and II. Trans. A.D. Godley (London and Cambridge, MA, 1926), book II.

5 Strabo, *Le voyage en Égypte*, trans. P. Charvet, preface by J. Yoyotte, commentary by J. Yoyotte and P. Charvet (Paris, 1997).

6 P. Schaff, ed., *Nicene and Post-Nicene Fathers*, series 1, vol. 12: *John Chrysostom, Homilies on the Epistle of Paul to the Corinthians*, rev. with additional notes by T. W. Chambers (Buffalo. NY, 1889), Homily XXVI.

7 The encounters between the crusaders and Saladin are discussed in Y. Lev, *Saladin in Egypt* (Leiden, 1999).

8 See M. Labid, *Pèlerins et voyageurs au mont Sinaï* (Cairo, 1961); J.-M. Carré, *Voyageurs et écrivains français en Égypte*, I (Cairo, 1956); P. Belon du Mans, *Les observations de plusieurs singularitez et choses mémorables trouvées en Grèce, Asie, Judée, Égypte, Arabie et autres pays estranges* (Paris, 1553); A. Thevet, *Cosmographie du Levant* (Lyon, 1554); R. Solé, *L'Égypte, passion française* (Paris, 1997), pp. 15–21. On European encounters with Egypt until the nineteenth century, see S. Morentz, *Die Begegnung Europas mit Ägypten* (Berlin, 1968); M. Bommas, '"Wer Ägypten nicht sah, der kennt den Menschen nicht": Hessemers Reise in den Orient', *Friedrich Maximilian Hesemer (1800–1860): Ein Frankfurter Baumeister in Ägypten* (Frankfurt, 2001), pp. 53–67. See also M. Kalfatovic, *Nile Notes of a Hawadji: A Bibliography of Travellers' Tales from Egypt from the Earliest Time to 1918* (London, 1992).

9 O. El-Daly, *Egyptology: The Missing Millennium. Ancient Egypt in Medieval Arabic Writings* (London, 2005), pp. 103–4.

10 A.-P. Leca, *Les momies* (Paris, 1976).

11 S. H. Aufrère, *La momie et la tempête: Nicolas-Claude Fabri de Peiresc et la 'Curiosité Egyptienne' en Provence au début du XVIIe siècle* (Avignon, 1990).

12 M. Casciano, M. G. Iannello and M. Vitale, *Enciclopedismo in Roma Barocca: Athanasius Kircher e il Museo del Collegio Romano fra Wunderkammer e museo scientifico* (Padua, 1986); S. Donadoni, S. Curto and A. M. Donadoni Roveri, *L'Égypte du mythe à l'Égyptologie* (Milan, 1990), pp. 61–73.

13 A. Kircher, *Obeliscus Pamphilius, hoc est interpretatio nova et hucusque intentata obelisci hierogliphici quem non ita pridem ex veteri hippodromo Antonini Caracallae Caesaris, in agonale forum transtulit, integritate restituit et in urbis eternae ornamentum erexit Innocentius X Pont. Max* (Rome, 1650); A. Kircher, *Oedipus Aegyptiacus, hoc est universalis hipogliphicae veterum doctrinae, temporum, iniuria abolitae, instauration* (Rome, 1652–4).

14 See the relevant chapter in J.-M. Humbert (ed. in chief), *L'Égyptomanie à l'épreuve de l'archéologie. Actes du colloque international organisé au musée du Louvre par le Service culturel du musée du Louvre, les 8 et 9 avril 1994* (Brussels, 1996).

15 W. Dean and J. M. Knapp, *Handel's Operas, 1704–1726* (Oxford, 19942).

16 B. Étienne, 'L'égyptomanie dans l'hagiographie maçonique', *D'un Orient à l'autre. Des métamorphoses successives des perceptions et connaissances: Actes du colloque du Caire, 18–22 avril 1985 et autres études* (Paris, 1991), pp. 149–79.

17 See J. Assmann's seminal work *Die Zauberflöte: Oper und Mysterium* (Vienna, 2005). On the links between Freemasonry and the opera, see also E. Istel and T. Baker, 'Mozart's "Magic Flute" and Freemasonry', *Musical Quarterly*, XIII/4 (1927), pp. 510–27.

18 K. J. Hartswick, *The Gardens of Sallust: a Changing Landscape* (Austin, TX, 2004), p. 130, no. 257.

19 The development of archaeology in Egypt since Napoleon is discussed in D. M. Reid, *Whose Pharaohs? Archaeology, Museums and Egyptian National Identity from Napoleon to World War I* (Berkeley, CA, 2002).

20 On the French expedition see G. Guémard, *Histoire et bibliographie critique de la Commission des sciences et des arts et de l'Institut d'Égypte* (Cairo, 1936); F. Charles-Roux, *Bonaparte gouverneur d'Égypte* (Paris, 1936); F. Charles-Roux, *Les origines de l'expédition d'Égypte* (Paris, 1910); C. La Jonquière, *L'expédition d'Égypte, 1798–1801*, 5 vols (Paris, 1899–1905); H. Laurens, *Les origines intellectuelles de l'expédition d'Égypte* (Istanbul and Paris, 1987).

21 J.-C. Galvin, 'L'expédition en Haute-Égypte à la découverte des sites', *L'expédition d'Egypte*, ed. H. Laurens (Paris, 1989).

22 The findings of the Franco-Tuscan expedition were posthumously published in J.-F. Champollion, *Monuments de l'Égypte et de la Nubie* (Paris, 1845).

23 A. Lebas, *L'Obélisque de Luxor: Histoire de sa translation à Paris, description des travaux auxquels il a donné lieu, avec un calcul sur les appareils d'abattage, d'embarquement, de halage et d'érection* (Paris, 1839).

24 Mariette published extensively on the topography, monuments and hieroglyphic texts of Egypt. See for instance A. Mariette, *Karnak: étude topographique et archéologique avec un appendice comprenant les principaux textes hiéroglyphiques découverts ou recueillis pendant les fouilles exécutées à Karnak* (Leipzig, 1875); idem, *L'Égypte de Mariette: Voyage en Égypte par Auguste Mariette Pacha* (Paris, 1878). On the transformation of Egypt's archaeological landscape under Mariette see E. David, *Mariette Pacha, 1821–1881* (Paris, 1994); G. Lambert, *Auguste Mariette, l'Égypte ancienne sauvée des sables* (Paris, 1997); P. Brochet, B. Seguin, E. David and C. Le Tourneur d'Ison, *Mariette en Égypte, ou, La métamorphose des ruines* (Boulogne-sur-Mer, 2004).

25 A. Edwards, *One Thousand Miles Up the Nile* (London, 1877), chap. XXII.

26 See Mariette's detailed booklet on the Parc d'Egypte: A. Mariette, *Exposition universelle de 1867: Description du Parc égyptien* (Paris, 1867).

27 E. David, *Gaston Maspero, 1846–1916* (Paris, 1999).

28 Edwards, *One Thousand Miles Up the Nile*, chap. IX.

29 T. Gautier, 'Le pied de momie', *Le Musée des familles* (September 1840).

30 Travelogues by François-René de Chateaubriand, *Itinéraire de Paris à Jérusalem* (Paris, 1811) and Alphonse de Lamartine, *Souvenirs, impressions, pensées et paysages, pendant un voyage en Orient, 1832–1833* (Brussels, 1835) introduced Egypt to Europe. Egypt was viewed from a European perspective of cultural and intellectual superiority. This feeling is also encountered in contemporary works of art created by Orientalist painter-travellers, such as Edward Lear, John Frederick Lewis, Eugène Delacroix, Jean-Léon Gérôme, Ludwig Deutsch and Leopold Carl Müller, who recorded Egyptian harems, street life, baths and markets, and the interaction of contemporary Egyptians with the architectural remnants of their country. See L. Thornton, *The Orientalists: Painter-Travellers, 1828–1908* (Paris, 1983).

31 S. Colby, 'The Literary Archaeologies of Théophile Gautier', *CLCWeb: Comparative Literature and Culture*, VIII/2 (June 2006); http://docs.lib.purdue.edu/clcweb/vol8/iss2/7/. Less benevolent mummies feature in 'The Ring of Thoth' (1890) and 'Lot 249' (1892) by Arthur Conan Doyle, and in *The Jewel of Seven Stars* (1903) by Bram Stoker.

32 T.G.H. James, *Excavating in Egypt: The Egypt Exploration Society, 1882–1982* (London, 1982); P. Spencer, ed., *The Egypt Exploration Society: the Early Years* (London, 2007).

33 D. Rathbone, 'Grenfell and Hunt at the Oxyrynchus and in the Fayum', in Spencer, ed., *The Egypt Exploration Society*, pp. 195–229.

34 H. Carter, *The Tomb of Tut-Ankh-Amen, Discovered by the Late Earl of Carnarvon and Howard Carter*, 3 vols (London, 1923–33); N. Reeves and J. H. Taylor, *Howard Carter before Tutankhamun*, exh. cat., British Museum, London (London, 1992); T.G.H. James, *Howard Carter: The Path to Tutankhamun* (London, 1992).

35 J.-M. Humbert and C. Price, eds, *Imhotep Today: Egyptianizing Architecture* (London, 2003).

36 On the extensive collection of Coptic art in the Benaki Museum, see the online database available at http://www.benaki.gr. A selection of the artefacts is also discussed in D. Fotopoulos and A. Delivorias, *Greece in the Benaki Museum* (Athens, 1997).

2

Travels to the Beyond in Ancient Egypt

Martin Bommas

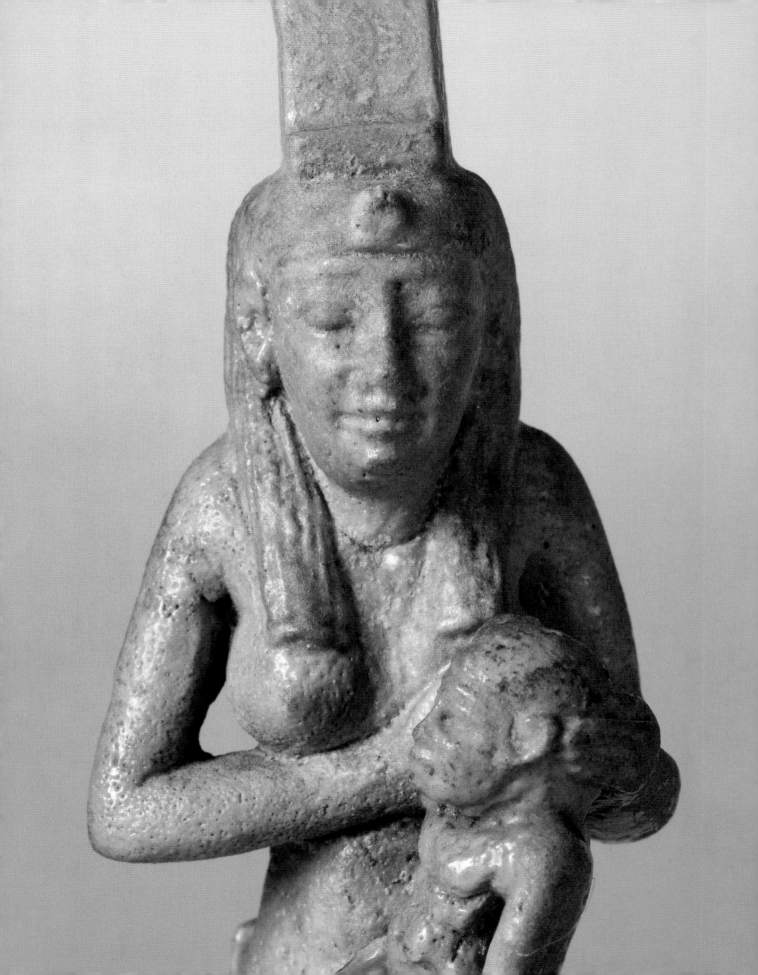

Probably the most visible aspect of the Profane's encounters with the Sacred in ancient Egypt was the treatment of death in its various facets. Here, taking place at irregular times and therefore distinguishable from official festivals that were rooted within ancient Egypt's religious calendar, ordinary people were able to catch a glimpse of aspects of ritual life. Whenever an individual died and was carried to his resting place, a large funeral cortège was expected to attend the various stages that accompanied the coffin's journey to the necropolis. Here, the distance between the profane world and the sacred would gradually decrease the closer the cortège came to the necropolis.

The Three Stages of a Burial in Ancient Egypt

Alongside these more public events, sometimes celebrated with pomp and circumstance, there was always also a more secluded approach to which no-one but the deceased himself and priests had access. This sphere was located in the embalming chambers, ideally installed on the East bank of the River Nile within reach of the settlements. In these mortuaries, the dead individual would have been transformed into an Osiris NN,[1] the mechanics of which will be discussed later. Here, the deceased would gradually lose his profane identity in order to encounter the sacred equipped with his own sacred sphere.

Finally, a third aspect of the treatment of death in ancient Egypt is located in front and inside an individual's tomb, where the deceased was supposed to be dismissed by his family. During this final step the sacred deceased would be separated from the profane for good.

Mediating between the Sacred and the Profane

These three steps certainly do not portray the chronological order of events. Any funerary rite would have started in the embalming chamber and continued with the funerary procession before finally reaching the forecourt of the tomb.[2] In fact, this chronological order closely follows the Egyptian perspective, which understands a dead individual to live simultaneously within the three worlds of sky, earth and necropolis. The deceased's socialization in this tripartite world is only possible on the grounds of a balanced mediation between the sacred and the profane where everybody involved has to play his part to allow for a successful burial.

Mummification as a Rite of Passage

When dealing with death in ancient Egypt, all these three components of social interaction have to be assessed likewise: from mummification rites to the funeral procession and finally to the rites that accompanied the rituals within the burial chamber.

This rather complex journey to the beyond started within the mortuaries. Here, a dead individual ideally underwent the process of mummification. A variety of methods of preparing

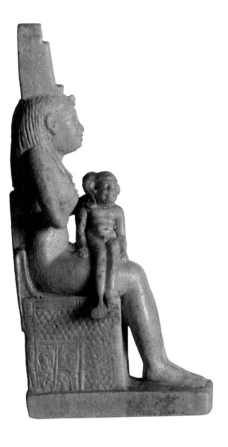

Opposite, above
18. Statuette of Isis suckling her child Horus, Third Intermediate Period, 15 × 7 × 4.5 CM., *Myers Collection at Eton College ECM 1717.* According to the myth, Isis, sister and wife of Osiris, raised Horus in the Delta marshes. He would later follow his father on the throne of Egypt.

37

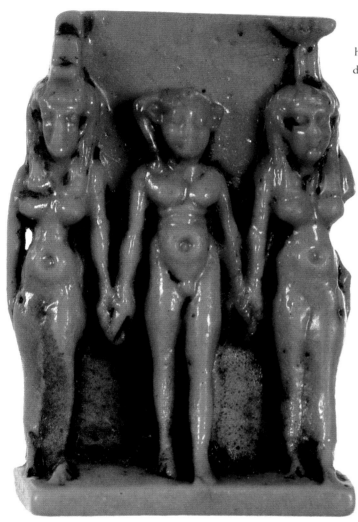

the dead body could be chosen, each adapted to an individual's financial means. Backed by ancient Egyptian sources written in hieroglyphs, the Greek historian Herodotos (*c.* 484–*c.* 425 BC) describes the three main methods available in full detail.[3] However, what was even more important than the physical treatment of the dead body was to be buried as Osiris, thus following the mythical role of the god of the underworld. This change of status from profane to sacred was based on a linguistic treatment of the dead body. As we will see later, these speeches also took place in the embalming chamber and were no less an important part of the process of mummification.

The Myth of Osiris

The reconstruction of the myth of Osiris is paved with obstacles, the first of which lies in the fact that ancient Egyptian sources do not give a full account. Instead, only certain allusions to mythical events can be found in religious texts. The myth as a narrative would probably have been completely hidden, if it were not that Greek sources, such as books written by Plutarch and Diodoros Sikelos, have been available that preferred a more narrative approach, aiming at explaining the secrets of ancient Egyptian secret life from a naturally more academic viewpoint. Their distant views, however, allow for a more global picture that is notoriously lacking in ancient Egyptian sources, due to the fact that myth in Egypt was kept hidden and not publicly discussed or displayed as in ancient Greece. In brief, Osiris was a ruling king of Egypt who was killed by his brother Seth. His dead body was left on a stretch of sand, exposed to the burning sun, and his body fluids drained away, forming first a brook and then the River Nile. While the former king's body continued to decompose, his bodily members separated and floated away downstream. His sister and wife Isis (fig. 18) – aided by a crocodile and her sister Nephthys – searched for the king's dead body. With the help of her magical skills she managed to re-member (the English word describes this situation in ideal terms) Osiris. After his body parts were reunited, Isis decided to conceive Horus in a posthumous act that is not described in any great detail by the ancient sources. Raised in the Delta marshes by his mother Isis and his aunt Nephthys (fig. 19), Horus was supposed to become king of Egypt, thus following in the footsteps of his father, who by then ruled the netherworld. But Seth, who still longed for the kingdom of Egypt, disputed

Above

19. Triad consisting of Isis, Harpokrates and Nephthys, Late Period, 2.5 × 1.5 × 0.5 CM., *Myers Collection at Eton College, ECM 1558.* This amulet, which portrays Harpocrates or Horus-the-Child accompanied by Isis and her sister Nephthys, emblematizes the deceased's wish for protection. In offering this, Horus stands in for his father Osiris in the struggle against Seth, personification of all netherwordly evils and perils.

Horus' enthronement, at first with violence though the matter was eventually settled in court (fig. 20).[4] Horus was declared rightful heir of the throne of Egypt while Seth had to content himself with the role of the notorious enemy of Horus and Osiris. The birth of Horus-the-Child, a form of Horus that needs to be distinguished from Horus-the-Elder, leads to the myth of Horus, which must be separated from the myth of Osiris.

Osiris as Mythical Antecedent

The myth of Osiris became the prototype for the treatment of any individual's death, provided he or she was wealthy enough to afford the costs involved. Osiris' name is attested for the first time in the funerary chapel of Djedkara-Isesi (c. 2410–c. 2380 BC) and later in the Pyramid Texts (after 2350 BC) written on the walls of the pyramids' inner chambers, in which the dead king equals himself with his divine predecessor (fig. 21). Archaeological sources, on

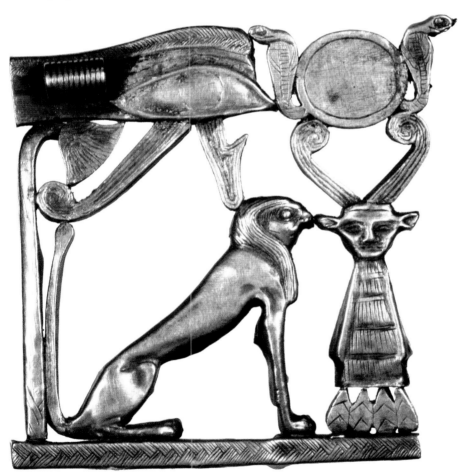

Left
20. Pectoral ornament (detail), Middle Kingdom (12th Dynasty), probably from Dahshur, 6 × 4 × 0.5 cm., *Myers Collection at Eton College, ECM 1585*. Made of electrum (the reverse is set with semiprecious inlays, including lapis lazuli and carnelian), this rare example of a high-quality pectoral shows Horus as a falcon-headed sphinx on the left (seen here) and Seth on the right (not shown), flanking the emblem of the goddess Bat with a solar disc and two opposed Udjat-eyes. Horus and Seth symbolize the unification of Lower and Upper Egypt.

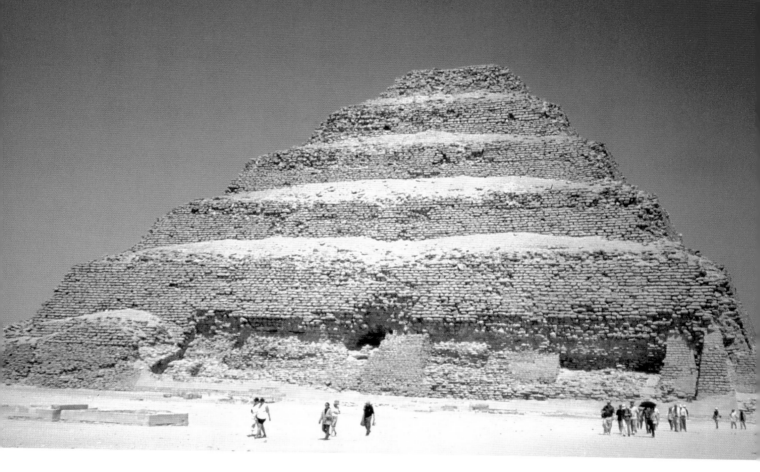

Above

21. The so-called Step Pyramid at Saqqara. View from the south over the Southern court of Djoser's funerary complex (3rd Dynasty). Underneath the pyramid the original step-mastaba is still visible. (Copyright: Maria Michela Luiselli)

Right

22. Causeway leading to the tomb of Khunes, Qubbet el-Hawa, 6th Dynasty. On both sides of the causeway false doors have been engraved into the living rock so that other dead individuals may receive offerings from passers-by. (Copyright: Martin Bommas)

the other hand, point to the fact that the rituals connected with the treatment of Osiris' death started earlier than the earliest textual attestations suggest. In order to ensure the safe arrival of the coffin before the tomb, extensive stone causeways were constructed so that funerary processions, after leaving the embalming chamber, could cross the fertile land and then over the Nile to the burial places ideally situated in the East (fig. 22). These causeways also guaranteed a sacred space in which the journey to the beyond could take place safely, flanked by singers, and without giving Seth any opportunity to interfere with the highly vulnerable funerary rituals, which were to be kept clear of disturbances or alterations. This linear concept was first introduced when the pyramid of Snofru (*c.* 2670–2620 BC) was built at Dahshur. Older Pyramid complexes, such as the one established by Djoser (*c.* 2720–*c.* 2700 BC) at Saqqara, favoured more loosely connected rites and a surrounding temenos wall instead. Djoser's Step Pyramid, however, is by no means to be regarded as less sacred: in fact this complex was called *djeser*, the Egyptian word for 'sacred, distant, separated'. By the Old Kingdom his complex in the desert, surrounded by high walls, had already become a symbol of *djeser* equivalent to Osiris' role in a successful passage to the underworld.

Dying to Live

The linear funerary procession connected with Osiris opened the possibility for audiences to follow the deceased's coffin to his tomb. Gestures of mourning and the performance of mourning songs accompanied the burial processions (fig. 23). This collective farewell both demonstrated the deceased's power on earth and safeguarded his precious tomb equipment on its long way from the embalming chamber to the tomb (fig. 24), the dead individual's final resting place (fig. 25). Incantations often stress the fact that death is regarded as an illness that can be healed through ritual. Those whose rituals fail, who are rejected in the judgement of

Below

23. Ten women raising their hands to their faces in a gesture of lamentation accompany the burial rites. Behind them a lavishly arranged offering table is prepared for Kinebu's own needs. Lithograph by Robert Hay (1799–1863) of a mourning scene in the Tomb of Kinebu (TT 113), Thebes, 20th Dynasty (from M. Werbrouk, *Les Pleureuses dans l'Égypte ancienne*, Brussels, 1938, fig. 28).

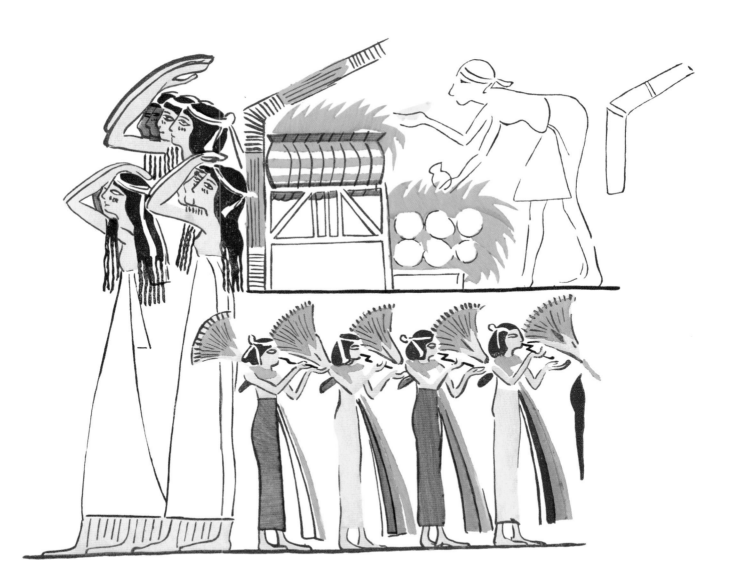

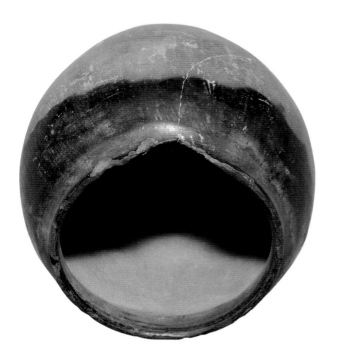

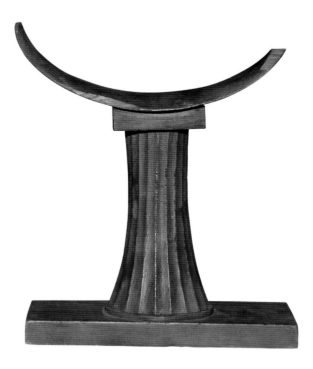

Above, left

24. Burnished black-topped redware vessel, later Predynastic period, *ECM 843*. Black-topped vessels are a common fineware even in poorer burials of Predynastic cemeteries. They were most likely filled with provisions for the afterlife. The characteristic black rim was achieved by placing the vessel upside down in the kiln, thus causing a reduction of oxygen. The remarkable shiny finish was created by polishing (burnishing) the vessel with a hard object, such as a pebble.

Above, right

25. Wooden headrest, Middle Kingdom, *ECM 1796*. Common to homes and tombs alike, headrests have survived in considerable numbers. Those made of wood were usually used in wealthy households but also made their way into tombs. Here, they supported a deceased's head during his passive awake state.

the dead or who suffer from an attack by Seth and his gang, have to die a second time with no return to 'life' possible. It is from this perspective that 'going away', a euphemism for dying the first death, can be understood as an ideal state:

> Oh, NN, you have gone while you live, you have not gone while you are dead.
> You have gone while you are glorified at the head of the glorified spirits
> and while you have power at the head of the living.[5]

Parallel Life

Although the idea at first may appear paradoxical, the deceased, glorified through mortuary liturgies, should be seen as literally leading the funerary procession to his own burial. This journey was based on an unalterable schedule: setting off at daybreak, when the first rays of the sun touched the embalming chamber, the coffin had to arrive in front of the tomb no later than midday. The so-called Ritual of Opening the Mouth then commenced, using the full power of the noonday sun for a purification rite that was again accompanied by incantations (figs. 26 and 27). Until then the deceased had travelled to his tomb only physically, as an object lying in his coffin (fig. 28). Simultaneously he was thought to travel the sky, where he

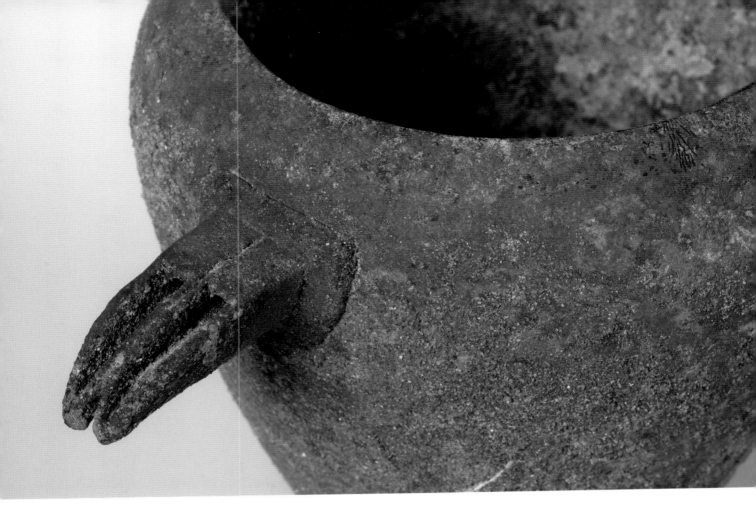

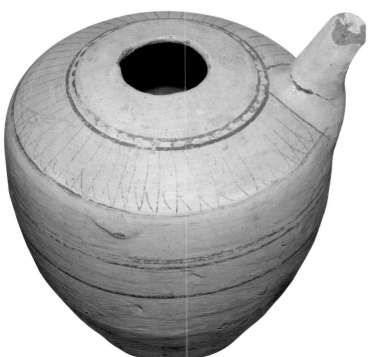

Above
26. Nemset-jar, copper, probably Old Kingdom, *ECM 1837*. Jars with spouts like the one shown here were used during purification rituals that formed an integral component of ancient Egyptian ritual practice. Perhaps the best-known context for their use is at the beginning of the Ritual of Opening the Mouth, which was performed in front of the uplifted mummy in the open tomb courts. Accompanied by the incantation 'Pure, pure', a nemset-jar was often the first object used in the ritual, alongside a bowl and a basin to collect the water used.

Left
27. Nemset-jar, ceramic with blue paint, New Kingdom, *ECM 1908*.

Left

28. The deceased's mummy is carried to the tomb as the sun rises over the horizon. Tomb of Thaty, Oasis of Bakhariya (from M. Bommas, 'Das Motiv der Sonnenstrahlen auf der Brust des Toten', *Studien zur altägyptischen Kultur*, XXXVI (2007), p. 21, fig. 1).

Below

29. Pectoral of Osiris, travelling in the sun-barque. Faience, probably New Kingdom, 11 × 7.5 × 1 CM., *Myers Collection at Eton College, ECM 814*. A common wish of the deceased as attested by New Kingdom funerary texts was to see Amun and Ra every morning to guarantee eternal life and rejuvenation. This pectoral shows the deceased as Osiris travelling in the sun-barque, flanked by Amun with his double-feathered crown (left) and the falcon-headed sun-god Ra (right).

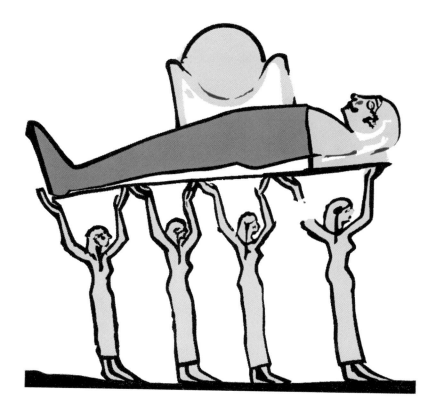

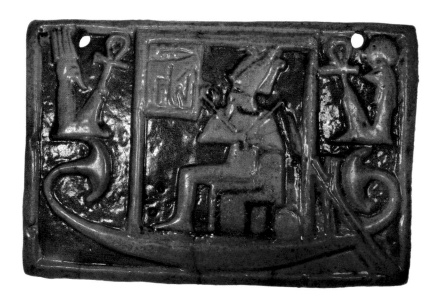

would enter the barque of the sun-god Ra. This is an important stage on the way to a new life: equipped with his new identity as an Osiris NN, he would make his first encounter with the divine. A text written on a box coffin from the Middle Kingdom says:

> you may consort with Ra.
> […]
> Ra has given you your beautiful ways which are therein [i.e. the horizon];
> the gates of the sky will be thrown open for you,
> for Ra has commanded that you shall be the ruler of his thrones there.[6]

The purpose of this journey was to bring the deceased for sentencing before the judgement of the dead, a court that the deceased wants to leave 'justified' without any accusation being brought forward against him. This concept is widely elaborated in the Book of the Dead (chapter 125), a collection of spells designed to help the deceased during his journey to the underworld.[7] By the Middle Kingdom the ambitions of the deceased have increased:

> May you have power over your body, may you ascend to the Great God [i.e. Ra].
> May you hear the words of vindication
> from Ra, the Great God.
> You shall not perish, your members shall not be destroyed, you shall not become weary,
> you shall not be wiped out for your body, eternally.[8]

The dead individual's wish to unite with the sun-god continued indefinitely: on the stela of Paheri in his tomb of the 18th Dynasty in El-Kâb, the deceased hopes to see Ra and Amun every morning to sweep away the perils of the night:

> May you see Ra in the horizon of the sky
> and may you face Amun when he rises.
> May you awake beautiful every day,
> every obstacle will be removed from you.[9]

In fact, the dead individual seeks to be in close vicinity with both Ra and Amun, from whom he expects to have permission to attend earthly festivals after his burial:

> May you follow god every day,
> may you see Amun-Ra in his appearance.
> May I see Amun after he appeared
> on his procession of his city.[10]

While travelling with Ra to the final judgement predated the actual burial, the wish of the deceased to come close to Amun and Ra was deeply rooted in his otherworldly existence. Only a very few objects of funerary art broach this issue, such as a pectoral depicting Osiris travelling in a barque and flanked by Ra and Amun (fig. 29).

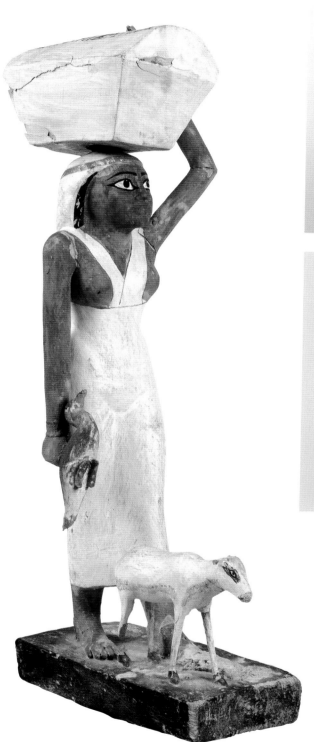

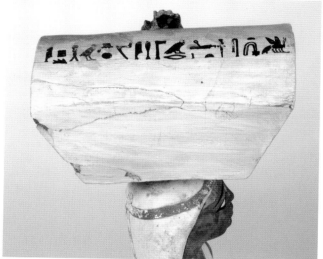

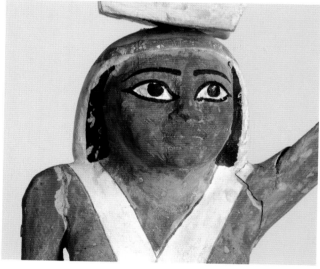

This page

30. Female offering-bearer of Hapikem, Late Old Kingdom, 45 × 20 × 20 CM., *Myers Collection at Eton College, ECM 1591.* Model figures of offering-bearers ensured everlasting provisions and offerings for the deceased, necessary to survive the perils of travel to the beyond and for his netherworldly existence. This dark-skinned offering-bearer walks beside a white calf and grasps a duck in her right hand while balancing a white chest on her head with her left hand. The carefully written hieroglyphic inscription on the chest's lid gives the deceased's titles and name: "Seal-bearer of the King of Lower Egypt, Sole Friend, Overseer of Priests, the honoured one, Hapikem". Hapikem is known to have been the owner of tomb A4 in the necropolis of Meir, excavated by G. Daressy and A. Barsanti at the end of the nineteenth century.

Once the funerary procession had reached the tomb (fig. 30), the offering rites would commence with the first and probably most essential part, the Ritual of Opening the Mouth. This ritual, usually carried out by the deceased's heir playing the divine role of Horus, aimed at uniting the deceased's body, which was kept in its coffin, and his *ba*, a personal constituent that the ancient Greeks tentatively translated as *psyche*. Separated from one another as a result of physical death, without this unification of corpse and *ba* the deceased would not be able to use his limbs, his eyes, his mouth or anything else in the next world. By this point, the dead individual would have fully achieved the rank of an Osiris NN. From now on he would be able to live his life in the beyond and receive offerings. Placing the coffin in the burial chamber and sealing it at a later stage did not alter or increase this new status, but marked the end of the deceased's travel to the beyond.

Physical Treatment of the Dead in Ancient Egypt

Neither the journey to the beyond during the funerary procession nor the burial itself would have been possible without two important and preceding factors, the physical and linguistic treatment of the dead individual. Following the mythical example of Osiris, each dead body underwent a series of actions aimed at preparing it for eternal life and preventing it from being destroyed through the ravages of time or suffering from the attacks of Seth and his gang. Before the advent of the Osirian funerary belief, the bodies of those who could afford a burial were often wrapped in mats and buried in sandpits, finally becoming what is described as sun-dried mummies, such as the predynastic mummies from Hierakonpolis found in 1997, which already show traces of being wrapped in linen (*c.* 3600 BC).[11] A new approach that vastly developed during the Old Kingdom identified bodily liquids as the source of decay.[12] By using new methods such as evisceration, which was first applied to Khufu's mother, Queen Hetepheres (*c.* 2600 BC), the process of autolysis was slowed down, so enabling more elaborate and effective ways to cope with the fact that three-quarters of the human body consists of water. Crucial factors were the extraction of the brain and inner organs,

31. Canopic jar lid, New Kingdom, *ECM 501*. Canopic jars contained the embalmed organs of the deceased, one each for liver, stomach, lungs and intestines. During the Middle Kingdom and the 18th Dynasty all four canopic jars have human heads representing Horus, the protector of his father Osiris, including his organs.

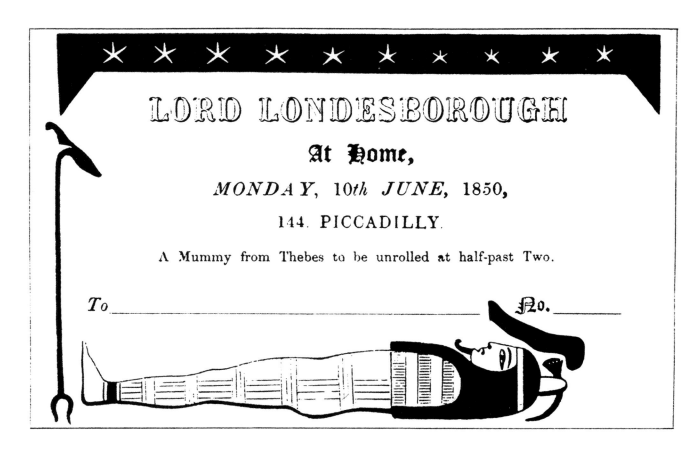

LORD LONDESBOROUGH

At Home,

MONDAY, 10th JUNE, 1850,

144. PICCADILLY.

A Mummy from Thebes to be unrolled at half-past Two.

To_____ No. _____

Above

32. Invitation card to the 'unwrapping a mummy', Britain, 19th century.

which were set aside in special containers called canopic jars (fig. 31), dehydrating the body in natron, and restoring body parts such as teeth. Intensive scientific research that goes well beyond the use of X-rays has recently shed light on the technology used by the ancient embalmers,[13] while also opening a window on the lifestyle and diseases of those who could afford to be buried that way. Without doubt, fascination with the process of mummification and, especially, the hope of finding hidden secrets and treasures inside the mummy wrappings have always fuelled interest in ancient Egypt, although mostly not in an academic sense (fig. 32).

Acting through Speaking

What is largely overlooked in our modern, science-led approach to life is the importance of texts recited during the process of mummification. Funerary texts were absolutely crucial to the ancient Egyptian mind to prepare for the journey to the beyond and a carefree existence after one's physical death. On one hand, there are fragments of what is called the Embalming

Left

33. Wooden statue of Mesehty, end of 11th or beginning of 12th Dynasty, from Asyut, 63 × 25 × 25 CM., *Myers Collection at Eton College, ECM 2167*. This statue represents the deceased's ka, a personal constituent that can be described as one's double. Mesehty was mayor of Asyut. His tomb is well known for the fine coffins and models it contained (all in Cairo).

Below

34. Wooden stick from the tomb of Mesehty (detail), end of 11th or beginning of 12th Dynasty, from Asyut, 100 × 3.5 × 3.5 CM., *Myers Collection at Eton College, ECM 2168*.

Ritual, containing texts that were recited during each step of the embalmer's work: no precious amulet or inscribed mummy bindings would have found their correct position without these texts to guide the embalmers. On the other hand, no transfer from manual treatment into a mythical sphere would have been possible without the recitation of the right utterance at the prescribed time. If we were to describe the journey to the beyond as a means of introducing and socializing the deceased in the sacredness of the netherworld, only funerary texts – and above all mortuary liturgies[14] – would hold the necessary details. Read out loud in the embalming chamber during the nightly vigil, these liturgies consist of glorification spells of considerable length. Most of them contain complex mythical allusions. Their purpose is to introduce the dead individual into the sacred world of the netherworld as a glorified spirit by enforcing his reception in the next world through the help of well-meaning and welcoming gods. Others focus on the fact that Seth is already overthrown and contain the wishes of the dead, such as drinking from the water of the divine, eating with the gods and having free movement without being fenced in (which stands in contrast to being buried in a coffin, euphemistically called Lord-of-life). The Middle Kingdom statue of Mesehty from Asyut shows the deceased as a glorified spirit, proudly striding out (fig. 33). The presence in the tomb of Mesehty's walking stick, which he had used during his lifetime (fig. 34), convincingly underlines how the wish for free movement in the beyond was translated into funerary goods. Step by step, a profane body would thus be introduced into the beyond, embodied in the amulets depicting the divine and the funerary spells written on bindings to protect the deceased against the revenge of Seth.

The Sky-Goddess Welcomes the Newborn Deceased

According to the speech-act theory[15] spoken words open out into action. A passage from Papyrus Rhind I sheds some light on this practice. It mentions an image of Nut (here, the Egyptian word for image is *sesh*, 'writing') painted on the inside of a coffin. This 'image' also contains the accompanying text that Nut performs for the benefit of the coffin's owner:

> The writing of the image of Nut inside the coffin:
> 'Welcome in peace in your coffin.
> It is the place of your heart forever.
> My arms are spread in order to embrace your divine body.
> I will secure your body, I will protect your mummy,
> I will enliven your ba eternally, Osiris NN!'[16]

It is obvious that the second purpose of these spells is to soothe the newborn deceased with spells of mythical meaning. Most mortuary liturgies are aimed precisely at preparing the deceased for his new life in the next world. A common feature of these liturgies that had already

Left, below
35. Scene from the *Book of Amduat* (literally, 'what is in the underworld'), 21st Dynasty, 76 × 30.5 × 0.1 CM., *Myers Collection at Eton College, ECM 1573*. This sheet illustrates the 12th nocturnal hour, during which the sun-god Ra (middle register, left, in his ram-headed form) crosses the body of the snake and rejuvenates with the help of primeval gods.

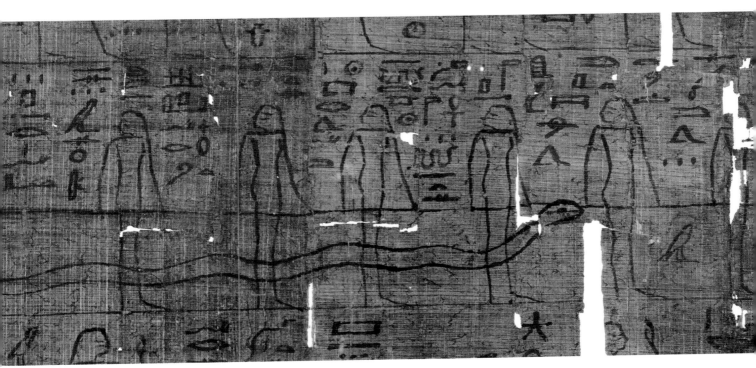

developed before the Pyramid Texts[17] is that these texts were performed *for* the deceased. Being the main corpus of texts by which the dead individual made his transformation from a profane individual to a divine being over a period of more than 2,500 years, mortuary liturgies and even extracted glorification spells were written on and inside coffins and on tomb walls. In Greco-Roman times they were updated and newly arranged to form part of the Osiris liturgies read from large papyrus book rolls and performed in temples all over Egypt.

Other religious texts that aided the dead individual on his journey to the hereafter were supposed to be read by the deceased *himself*, forming guidebooks to the netherworld. The so-called Book of the Dead is probably the best-known example of these texts and has survived

This page
36. Fragment from the outer coffin of the master builder Amenhotep, 18th Dynasty, Thebes, 84 × 30 × 20 CM., *Myers Collection at Eton College, ECM 1876.* Although incomplete, this coffin lid is an example of the fine craftsmanship to be found in Theban coffin workshops of the time.

in many copies on papyrus, some of them vividly illustrated. Netherworld guides such as the Amduat were restricted to royals and recorded in the tombs of the Valley of the Kings before the royal privilege expired by the end of the New Kingdom and the Book of Amduat became accessible for the elite (fig. 35).

In addition to the large corpora of religious texts, isolated glorification spells were equally held in high esteem. One of them is the Nut-formula, named after the sky-goddess.

The Coffin as a Shelter

A copy of this formula can be found on the inside of the coffin lid of Amenhotep, who was 'overseer of the builders of Amun' during the 18th Dynasty (1539–1292 BC), the first and probably most glorious dynasty of the New Kingdom (fig. 36). Amenhotep's tomb at Dra Abul-Naga (TT A7) is unfortunately lost but can nevertheless be quite well assessed from the many objects derived from his tomb that are now scattered around the world.[18] On the inner surface of the fragment of Amenhotep's coffin a fine yellow drawing of the goddess Nut can be observed on the black surface of the resin-coated coffin (fig. 37). It is followed by an inscription that contains the opening line of the so-called Nut-formula:

> Recitation.
> Overseer of the builders of Amun, Amenhotep, justified:
> Mother Nut spread [yourself over me …]

The combination of image and text seen on Amenhotep's coffin accurately reflects the passage from Papyrus Rhind I (see above). The Nut-formula of the New Kingdom, again, goes back to several spells within the corpus of the Pyramid Texts. From the Middle Kingdom Nut played an important role on two counts: firstly, she was the mistress of the skyscape of death; secondly, she was regarded as the mother who granted birth in the netherworld. By the end of the Middle Kingdom Nut was regarded as the guardian of the coffin lid, in which role she is portrayed on the inside of Amenhotep's coffin. As such she was believed to guide the dead individual to the land of light that stands in contrast to the darkness inside the coffin:

> May you step out to your mother Nut,
> so that she may take your hand
> and show you the way to the land of light,
> to the place where Ra is.
> May she throw open the gates of the sky
> and open for you the door-wings of the 'cool one' [a celestial area].[19]

Above
37. The underside of Amenhotep's coffin lid contains the opening lines of a prayer to the goddess of the sky, the so-called Nut-formula. *ECM 1876* (Copyright: Tomohiro Muda/Eton College).

Death in Ancient Egypt – the Brighter Side of Life?

What has been said so far might amplify the impression that the ancient Egyptians, regardless of their status and wealth, lived to prepare for their well-being in the netherworld; in other words they had no second thoughts about the effectiveness of the expensive mechanism of rituals, manuals and recitals. They might also have longed for an undisturbed tomb as a place to guarantee a secure existence in the world beyond, equipped with everything necessary for a lasting stay (figs. 38–40). It should be stated that indeed the majority of surviving texts support this view. Only a short series of isolated spells found inscribed on the ceilings of wealthy private tomb owners, mainly from Thebes, paint a different picture. Here tomb owners describe their individual approaches to death and name individual preparation as the key to their future life. Ancient Egyptian literature, especially fictional literature, is not exactly short of passages globally referring to the need to make early preparations for one's death.[20] For a short period of time, however, roughly forty known inscriptions point out the need for becoming active individually:

> Blessed by god
> Is the noble one who acts on his own behalf with regard to his future
> And who searches with his heart to find for himself salvation,
> The burial of his corpse and making his name live,
> The one who thinks of eternity.[21]

Below, left
38. Ushabti of the scribe Mai, 18th Dynasty, 7.5 × 3.5 × 2.5 CM., *Myers Collection at Eton College, ECM 378.*

Below, centre
39. Ushabti, Third Intermediate Period, Bab el-Gasus (Deir el-Bahri priests' cache, tomb DB B) 14 × 4 × 3 CM., *Myers Collection at Eton College, ECM 395.*

Below, right
40. Ushabti, Third Intermediate Period, 11 × 4 × 3 CM., *Myers Collection at Eton College, ECM 398.*

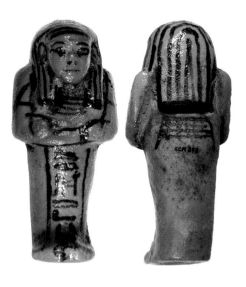
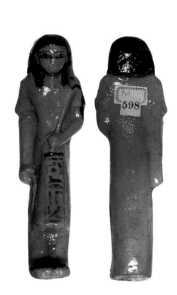
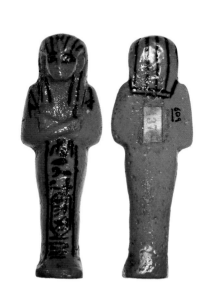

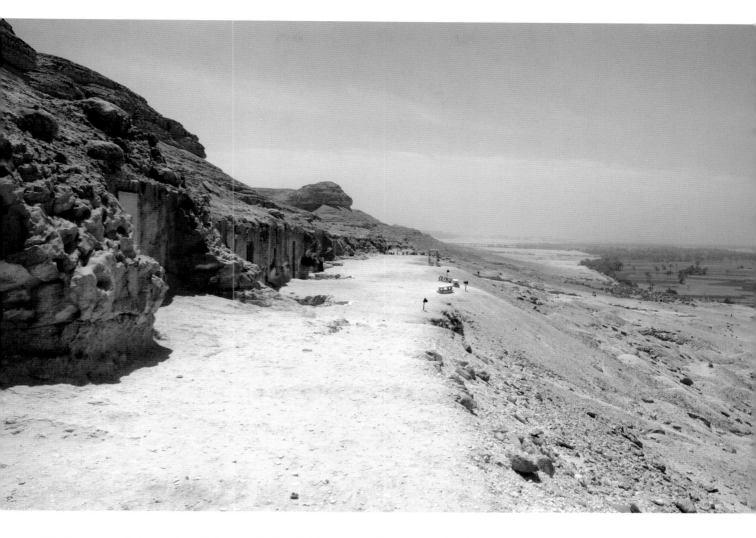

The fact that inscriptions such as this from tomb 61, which belonged to Useramun, are found on ceilings identifies them as communications with the sky-goddess Nut. Encountering the sacred was therefore not taken lightly: where the profane met with the sacred a border was felt to exist that manifested itself in tomb ceilings or inner surfaces of coffins, both membranes to the beyond overseen by the divine.

Profane Approaches to the Sacred

Before the Middle Kingdom individual approaches to death can only rarely be identified; the majority of dead individuals received a standardized treatment.[22] This does not mean, however, that individual solutions did not exist alongside the usual decorum. Where personal belongings made their way into burials they were designed to identify a person's wealth and taste. However, in most cases it is difficult, for example, to separate pottery collected and

Above

41. Upper terrace with rock-cut tombs of the governors of the 16th Upper Egyptian Nome at Beni Hassan, viewed from the north with the fertile land and Nile to the right. Recently described as the 'quintessential necropolis of the Middle Kingdom' (Aidan Dodson), Beni Hassan is one of the rare necropolises where the smooth shift from the early to the classical Middle Kingdom can be observed in every detail. Tomb 420 cannot be located with certainty today, but is expected to be found at the lower terrace to the right. First Intermediate Period.

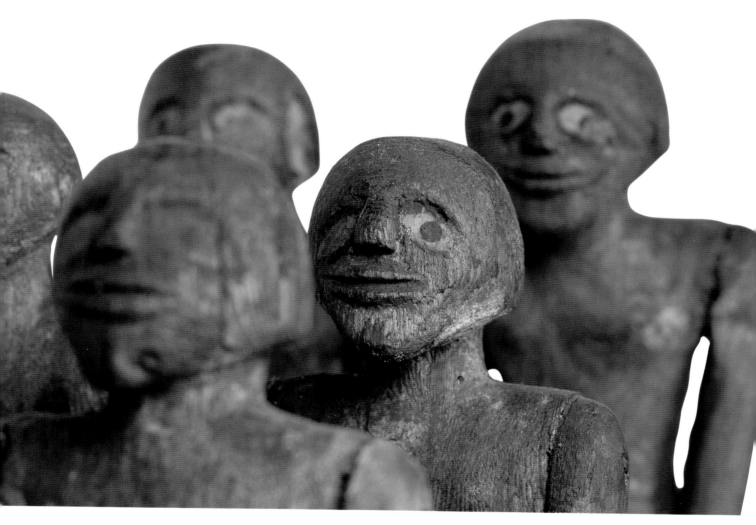

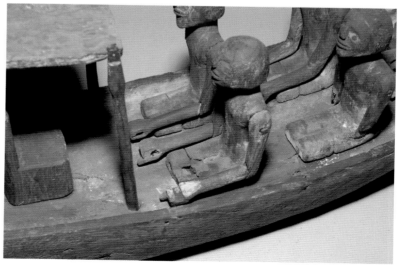

This spread

42. Wooden model of a rowing boat, 110 × 29 × 19 CM., *Myers Collection at Eton College, ECM 1550*. On the deck is a canopy beneath which the throne of the deceased, transformed into Osiris NN, can be seen. The helmsman sits at the stern facing six oarsmen ready to obey his commands. The pilot, usually standing at the bow to test the depth of water, has broken off. Similar models of boats can be found in many middle-class tombs of the Middle Kingdom, where the impractical nature of having tomb paintings gave way to models securing the abundance of food offerings and the dead individual's free movement.

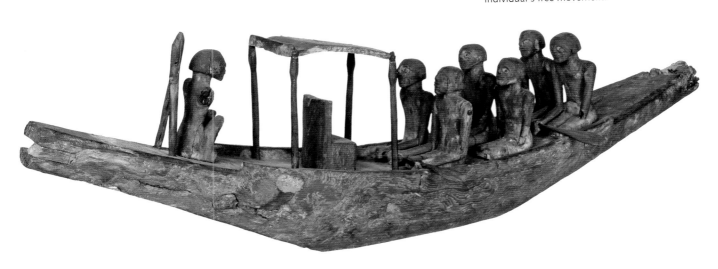

esteemed during someone's lifetime and objects that were specifically produced as funerary goods. Moreover, the business of death in ancient Egypt was always undertaken on an industrial scale, leading even to prefabricated copies of the Book of the Dead personalized only after purchase. Genuinely individual approaches seem to have occurred only rarely or were reduced to stating names, sometimes the provision of tomb owners' (auto-)biographies and the choice of recitation texts.[23]

Personal Funerary Goods

Apart from texts, it was certainly not common for funerary equipment to be individually chosen. An exception to this general rule, however, was found in a modest and largely overlooked rock-cut tomb at Beni Hassan, although its precise location is unfortunately

lost (fig. 41).[24] Numbered BH 420 by its excavators, this tomb offers a rich and unique selection of funerary equipment. When it was excavated in 1903–4 all its contents were listed and removed, but only two objects were photographed.[25] In addition, no archaeological documentation has survived. All the objects excavated during that season were given away to anyone who could afford postage and packaging, as promised in an advertisement in *The Times*,[26] so the contents of nearly 900 tombs were consciously spread all over the world, among them the funerary equipment of tomb BH 420. According to the excavators' brief notes, this tomb contained wooden models of a boat (see fig. 42 for a similar model) and a brewery, undoubtedly pointing to free movement and offerings in the netherworld (cf. figs. 33 and 34). An inscribed fragment of a wooden box coffin containing Pyramid Texts, as well as some pottery, suggests that BH 420 dates from the First Intermediate Period, which accords well with the overall funerary equipment found. Among these finds, however, there were two dolls. The larger one, which has unfortunately been lost, was made of wood and had long hair that a child could comb. The other one is a tiny and delightful figure, 7.5 cm in height, and made of flax with beaded hair (fig. 43).[27] The excavators suggested that BH 420 must have belonged to a child but nothing supports this view. Burial practices for children in ancient Egypt are still difficult to determine, although it is known that children were often buried separate from their parents.[28] Archaeological evidence from the settlement at Elephantine suggests that children were buried inside the houses where their families lived[29] or in abandoned dwellings nearby.[30]

A Membrane between this World and the Beyond

It is impossible to establish why an adult should choose to take two dolls with him on his journey to the netherworld. On the other hand it might be safe to say that a doll just 7.5 cm high can hardly be a toy to play with. Was the second doll a substitute or reminder of something dear lost long ago? No proof for such practice can be identified within the funerary literature. On the other hand, family tombs are frequently attested in ancient Egypt throughout history. These do not only serve the purpose of being more economical or more social. Another purpose deeply rooted in religious belief is that ancestors were expected to guide their relatives during their difficult journey to the beyond or to act as what has been described as the 'head of the living'. As a matter of reciprocity, the living had to take good care of their dead. One official occasion was the 'Beautiful Festival of the Valley', during which relatives congregated in their ancestors' tomb-courts to drink to the rejuvenation of the deceased using specially made dinner ware (figs. 44–48).

It seems understandable that extreme measures were favoured when it came to facing the unpredictable world of the sacred. All the precautions taken in facing the dangers of a second death, either in following the norm or challenging it, seem to point to the tomb as

Above
43. Doll with beaded hair from tomb BH 420 at Beni Hassan, First Intermediate Period, height 7.5 CM. This doll is too small for a toy and other finds inside the tomb do not indicate the burial of a child. *Myers Collection at Eton College, ECM 1843.*

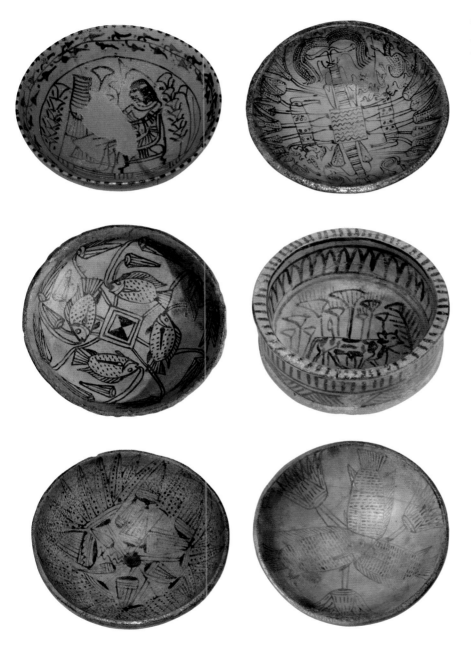

Top, left
44. Bowl, 19th Dynasty, 13.5 × 13.5 × 4.5 cm., *Myers Collection at Eton College, ECM 821.* These blue faience bowls, sometimes erroneously referred to as Nun (i.e. the primeval ocean)-bowls are attested as funerary equipment from the Middle Kingdom. Their later use, however, includes offering plates for the cult of Hathor.

Top, right
44a. Bowl shaped like a plate, 18th Dynasty, 18 × 17.5 × 5.5 cm., *Myers Collection at Eton College, ECM 1590.*

Middle, left
45. Bowl, 18th Dynasty, 15 × 15 × 5 cm., *Myers Collection at Eton College, ECM 1646.*

Middle, right
46. Plate with depiction of Hathor-cow, 19th Dynasty, 13 × 12.5 × 5 cm., *Myers Collection at Eton College, ECM 1758.*

Bottom, left
47. Bowl, 18th Dynasty, 15.5 × 15.5 × 6 cm., *Myers Collection at Eton College, ECM 1761.*

Bottom, right
48. Bowl, 18th Dynasty, 11 × 11 × 3 cm., *Myers Collection at Eton College, ECM 1880.*

the architectural expression of funerary belief. It is here where the border between sacred and profane in ancient Egypt can be located. In later periods this concept is even more elaborated. Inscribed ceilings of rock-cut tombs seem to engage in a dialogue with the sky-goddess, ensuring that this will be the glorified spirit's first encounter after being newly born in the beyond. Here, the tomb ceiling functions as a membrane through which the beyond can be reached.

Oscillating Presence of Glorified Spirits

The tripartite context described above exemplifies the several stages a dead individual had to pass before the actual burial could take place. It also suggests that the ancient Egyptians did not only distinguish between sacred and profane but favoured a more complex approach. The most widespread glorification formula distinguishes between three different worlds, all occupied by a dead individual simultaneously:

> Glorified in the sky,
> Mighty on earth and
> Justified in the necropolis.[31]

Anyone who successfully went through the three stages of passage – physical and linguistic preparation of the dead body, funerary procession and burial – would then be in the state to travel from profane toward sacred in person by means of rituals. However, he would eventually find himself in a tripartite world where the Sacred (sky) and the Profane (earth) meet at a place that has already been identified as an acting membrane, the tomb within the necropolis. Here is where the profane would continuously encounter the sacred, in an everlasting circle, any time the living visited their ancestors who had become Osiris NN in order to live in the beyond.

Endnotes

1 NN referring to *nomen nominatus*, a person's name. Osiris (the god) has to be distinguisehd from Osiris NN, a dead individual who has reached the state of being Osiris through rituals.

2 On the textual sources relating to ancient Egyptian funerary beliefs, see J. Assmann, *Death and Salvation in Ancient Egypt*, trans. D. Lorton (Ithaca, NY, and London, 2005). For a similar view based on archaeological records, see J. H. Taylor, *Death and the Afterlife in Ancient Egypt* (London, 2001).

3 *Histories* II.85–9; Herodotus, *The Histories*, trans. R. Waterfield (St Ives, 1998), pp. 126–8.

4 For the struggle between Horus and Seth, see M. Lichtheim, *Ancient Egyptian Literature* (Berkeley, CA, 1976), II, pp. 214–223.

5 PT [450] = Pyr. §833a–b; K. Sethe, ed., *Die altägyptischen Pyramidentexte* (Leipzig, 1908), I, p. 463.

6 CT [763] = VI.393c–h; A. de Buck, ed., *The Egyptian Coffin Texts*, VI (Chicago, 1956).

7 G. Lapp, ed., *Totenbuch Spruch 125*, Totenbuchtexte 3 (Basel, 2008). For an English translation see R. O. Faulkner, *The Ancient Egyptian Book of the Dead* (London, 1990), pp. 29–34.

8 CT [29] = I.81g–m; A. de Buck, ed., *The Egyptian Coffin Texts*, I (Chicago, 1935).

9 K. Sethe, *Urkunden der 18. Dynastie* (Leipzig, 1906), 117.6–10.

10 From TT 189, unpublished, see M. Bommas, 'Sepolture all'interno di corti templari in Egitto: il rinnovamento del rituale di sepoltura all'inizio del I millenio a.C.', *Aegyptus: Rivista Italiana di Egittologia e di papirologia*, LXXXV/1–2 (2005), p. 59 and n. 22.

11 R. Freedman, 'Excavations in the Predynastic Cemetery at HK43', *Nekhen*, IX (1997), pp. 2–3.

12 M. Lehner, *The Pyramid Tomb of Hetep-heres and the Satellite Pyramid of Khufu* (Mainz, 1985), pp. 30–31.

13 For one of the earliest scientific approaches, see J. E. James and K. R. Weeks, *X-Raying the Pharaohs* (New York, 1973).

14 J. Assmann, *Altägyptische Totenliturgien*, 3 vols (Heidelberg, 2001–8).

15 J. L. Austin, *How to Do Things with Words* (Oxford, 1962).

16 *Totenpapyrus Rhind* I, XI/5: *Die beiden Totenbuchpapyrus Rhind des Museums zu Edinburg*, ed. G. Möller (Leipzig, 1913).

17 For the use of the term 'glorified spirit' during the reign of King Snofru, see E. el-Metwally, 'Die Entwicklung der Grabdekoration in den altägyptischen Privatgräbern: Ikonographische Analyse der Totenkultdarstellungen von der Vorgeschichte bis zum Ende der 4. Dyn.', *Göttinger Orientforschungen*, IV/24 (1992), p. 73.

18 For a list of these items, see N. Reeves and S. Quirke, in S. Spurr and others, *Egyptian Art at Eton College. Selections from the Myers Museum*, exh. cat., Metropolitan Museum of Art, New York, and Eton College (New York, 1999), p. 24.

19 PT 422 = Pyr. § 756a–c; K. Sethe, ed., *Die altägyptischen Pyramidentexte* (Leipzig, 1908), I, p. 414.

20 See, for example, 'The Teaching of Merikare', *Ancient Egyptian Literature*, trans. M. Lichtheim (Berkeley, CA, 1973), I, pp. 102.

21 E. Dziobek, *Die Gräber des User-Amun Theben 61 und 131*, Archäologische Veröffentlichungen 84 (Mainz, 1994), pl. 98.

22 J. S. Seidlmayer, 'Vom Sterben der Kleinen Leute: Tod und Bestattung der sozialen Grundschicht am Ende des Alten Reiches', in H. Guksch, E. Hofmann and M. Bommas, *Grab und Totenkult im Alten Ägypten* (Munich, 2003), pp. 60–74.

23 A striking example is coffin B10C from the necropolis of el-Bersheh, whose owner, the nomarch Amenemhat, cites one mortuary liturgy three times; see L.H. Lesko, *Index of Spells on Egyptian Middle Kingdom Coffins and Related Documents* (Berkeley, CA, 1979), p. 33; J. Assmann, 'Spruch 62 der Sargtexte und die ägyptischen Totenliturgien', in H. Willems, ed., *The World of the Coffin Texts: Proceedings of the Symposium held on the Occasion of the 100th Birthday of Adriaan de Buck, Leiden, December 17-19, 1992* (Leiden, 1996), pp. 17–30.

24 For a site-plan see J. Garstang, *The Burial Customs of Ancient Egypt as Illustrated by Tombs of the Middle Kingdom* (London, 1907), pl. IV.

25 Ibid., p. 153, fig. 151.

26 18 February 1904; see S. E. Orel, 'Chronology and Social Stratification in a Middle Egyptian Cemetery', PhD thesis, University of Toronto, 1993, p. 20.

27 This figure has attracted considerable attention in the past, see N. Reeves and S. Quirke, in S. Spurr and others, *Egyptian Art at Eton College*, pp. 18–19; F. M. Valentín, 'La Muerte y las creencias funerarias', *Azules egipcios, pequeños tesoros del Arte*, exh. cat., Instituto de Estudios del Antiguo Egipto, Madrid (Madrid, 2005), p. 189.

28 R. Zillhardt, *Kinderbestattungen und die soziale Stellung des Kindes im Alten Ägypten: Unter besonderer Berücksichtigung des Ostfriedhofes von Deir el-Medineh*, Göttinger Miszellen Beihefte 6 (Göttingen, 2009), p. 87.

29 M. Bommas, 'Nordoststadt: Siedlungsbebauung der 1. Zwischenzeit und des Mittleren Reiches nordwestlich des Inselmuseums', in W. Kaiser and others, *Stadt und Tempel von Elephantine, 21./22. Grabungsbericht*, Mitteilungen des Deutschen Archäologischen Instituts, Cairo 51 (1995), p. 146.

30 C. v. Pilgrim, *Elephantine*, XVIII: *Untersuchungen in der Stadt des Mittleren Reiches und der Zweiten Zwischenzeit*, Archäologische Veröffentlichungen 91 (Mainz, 1996), pp. 36–7.

31 M. Bommas, 'NR.2. Der Spruch *wn n=k p.t* zur Niederlegung der Opferspeisen', in J. Assmann, *Altägyptische Totenliturgien*, II: *Totenliturgien und Totensprüche in den Grabinschriften des Neuen Reiches*, Suppl. z. d. Schriften d. Heidelberger Akad. d. Wiss., Phil.-hist. Kl. 17 (Heidelberg, 2005), pp. 147–77.

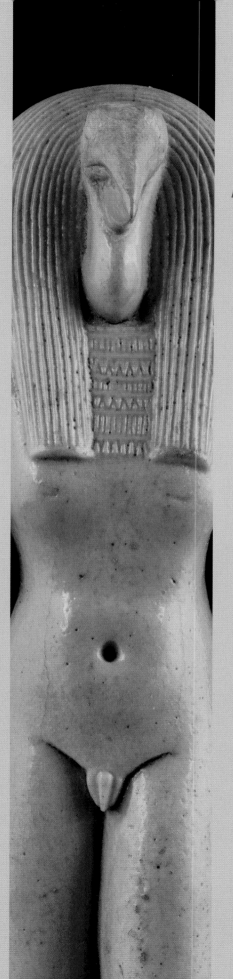

3

The Personal Approach to the Divine in Ancient Egypt

Maria Michela Luiselli

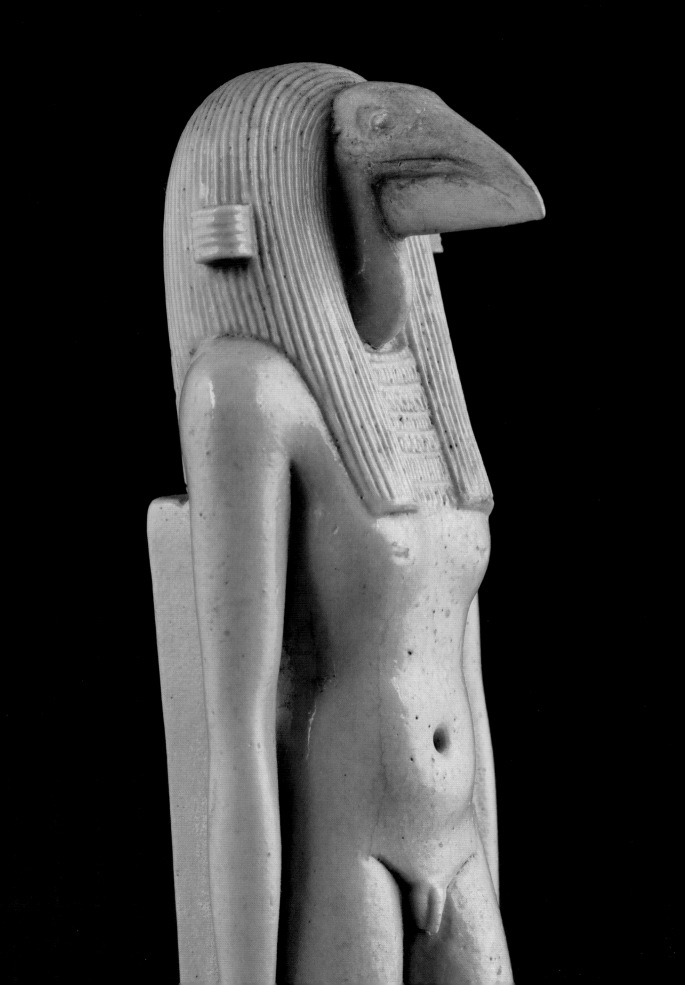

When practising religion one tries to approach a sacred dimension of which the divine is part: the profane life is left temporarily so that one may trespass the borderline to the sacred. Experiences of personal religious practice in ancient Egypt might have been different from ours in terms of their general aesthetics, structure and meaning. However, what they have in common with practical religion nowadays is the fact that they enact ways of approaching a sphere (the sacred) that is believed to be different than the sphere of everyday life (the profane). Part of this approach is 'piety' and 'devotion', which are (and were!) activated through religious practice.

Piety and Personal Religious Beliefs in Ancient Egypt: When the Gods Intervene in Human Lives

Bearing this in mind, it is first necessary to recall that the Egyptian language did not have specific terms that can be directly translated into 'religion' or 'piety'. Nevertheless, monuments and artefacts pertaining to what can be defined as religion are doubtless numerous and among the most relevant remains of the ancient Egyptian culture. Egyptologists face a huge quantity of religious texts, in addition to mobile and immobile archaeological installations, associated

Opposite
49. Statuette of Thoth (detail), Late Period, 13.5 × 4.5 × 3.5 CM., *Myers Collection at Eton College, ECM 1587.* This immaculate figure of the ibis-headed god Thoth was probably used as an amulet due to the two eyes set on either side of the wig. It could also be used as a temple statue standing on its small platform (not shown). His feet end in jackals' heads representing the god Upuaut, 'the Way-Opener'.

Below, left
50. Baboon representing the god Thoth, 18th Dynasty, 5 × 3 × 3 CM., *Myers Collection at Eton College, ECM 722.* Among many other functions, Thoth was the patron of the scribal profession, often represented by the figure of a baboon. Figures of the god were therefore often found in writing kits but also shown attending the judgement of the dead where Thoth helps in ascertaining the truth.

Below, right
51. Baboon representing the god Thoth, probably Middle Kingdom, 5 × 3 × 2.5 CM., *Myers Collection at Eton College, ECM 723.*

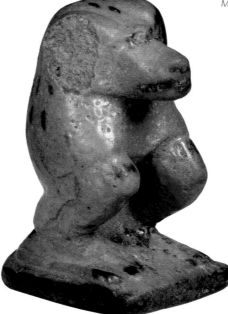

with temples and shrines as well as in the domestic context, and so coming both from the official 'state' cults and the dimension of private religious practices. Though widely discussed and not yet entirely solved, what Egyptologists call 'personal piety' is an aspect of ancient Egyptian religion that defines, in a broad sense, the religious sentiment and behaviour of an individual devotee to one or more specific superhuman agencies, with whom he or she felt directly involved.[1]

Personal religious beliefs and practices in Egypt are attested both in written sources and archaeology. Their display varied according to the rules of cultural decorum, that is to say to the non-written rules of content and form of cultural messages.[2] In other words, the way to express and display one's personal relation to a deity varied in time, the most evident being the written and visual forms of New Kingdom Egypt, mostly of the Ramessid period (19th and 20th Dynasties). Illnesses, suffering or particular events in life were interpreted as a divine intervention into man's personal life. Letters, literature, votive offerings and private monuments, so-called stelae, erected by one or more individuals within temple or shrine enclosures and dedicated to one or more deities, describe a feeling of dependence on a divine agency. An extract from the prayer stela of the workman Neferabu from Deir el-Medina,[3] dated to the 19th Dynasty, illustrates this in greater detail:

> […] I am a man who swore falsely
> by Ptah, lord of Maat,
> and he caused that I see darkness by day.
> I will proclaim his power to those who do not know him and those who do,
> to the small and the great.
> […] He made me like dogs of the street,
> while I was in his hand [power].
> He caused that people and gods look upon me as a man who had committed an
> abomination against his lord.
> Ptah, lord of Maat, was vindicated against me,
> And so he gave me an instruction.[4]

Neferabu is here publicly proclaiming the power of the god Ptah that he experienced by describing it as a punishment, because of the 'sin' that he had committed against him. Ptah made him suffer and abandoned him – as the metaphor 'I see darkness by day' suggests. He was forced to live away from the divine, left alone with his profane suffering and struggle. Only by declaring his own deeds, and by openly proclaiming the power of the god, often described in texts as the god's 'hand', was Neferabu able to ask for mercy and to return to normal life. All this was interpreted as an 'instruction', given by the god to the man.

Although texts like this, in which the experience of the divine power is described in detail, are comparatively rare in Egyptian culture, they doubtlessly characterize this historical period and point out the peculiar religious belief of that time. According to this belief, deities

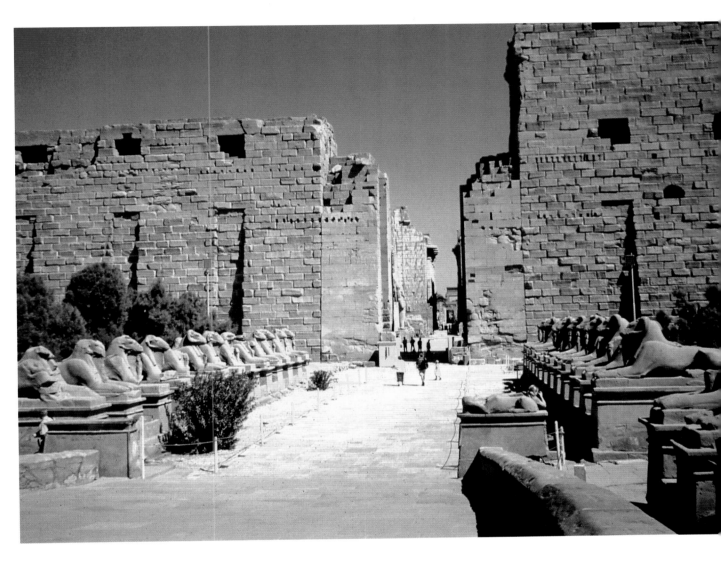

had both a benevolent and a malevolent nature. They could be merciful or dangerous; their intervention into one's life would be recognized in a particular personal success as well as in an illness or misfortune. This pattern was thus interpreted either as reward or punishment. In both cases it was the manifestation of a divine power that man had to declare openly and officially in front of its community during a religious act, the Egyptian term of this declaration being *sedjed bau* ('declaration of power').

Neferabu's prayer stela reflects that behind the admittance of sins committed against a god, the narration of the punishment received, and the proclamation of the divine power was the belief that the gods were aware of human deeds. It was crucial to identify which deity

among the many in the Egyptian pantheon intervened in one's life, because this placed the individual under the obligation to observe a particular devotion to him or her. With reference to this, it is worth mentioning that some Ramessid texts found at Deir el-Medina, written on ostraca, mention the existence of a 'wise woman' in the town, who was believed to be able to recognize the deity responsible for one's suffering.[5] Once this was clarified, anyone who experienced divine intervention in his or her life had to perform devotional practices and make offerings in order to turn the malevolent phase of the deity into a benevolent one.

Being Close to the Divine

Part of this belief in direct divine intervention in human life brought about the idea of the existence of a *personal* god. It certainly started much earlier – expressions such as 'my god/his god', for example, are attested in inscriptions from the Old Kingdom – but it found its highest development in the New Kingdom. Some texts and inscriptions now use the expression 'to put a god into one's heart'. According to Egyptian religious belief, the heart was the place of the mind: it was the heart that took decisions and guided one through everyday life. This is why, during the long procedure of mummification, the heart was treated in a way that enabled its reintroduction into the mummified body, protected by the heart amulet and thus continuing its function in the beyond. 'To put a god into one's heart' therefore meant that one was guided by a god, who was believed to be constantly close.

Above
53. View of the shrine of Ptah and Meretseger at Deir el-Medina. (Copyright: Martin Bommas)

This closeness became a crucial topic of self-presentation in Egyptian autobiographical texts and statements in the New Kingdom. Egyptian moral values were now centred on this. The authors of texts written on monuments in the public view – or the patrons that commissioned them – increasingly stressed how close they were to one or more gods. Piety, devotion and performing ritual actions became crucial aspects of one's self-presentation and, as stated above, a criterion of moral values during the New Kingdom. In a passage taken from the so-called 'Instruction of Ani', a literary text of the New Kingdom for the moral education of scribes and administrative staff through instruction in the right behaviour for everyday life, the alleged author Ani says:

[…] Do not raise your voice in the house of god,

He abhors shouting;

Pray by yourself with a lovely heart,

Whose every word is hidden.

He will grant your needs,

He will hear your words,

He will accept your offerings.

Offer libations for your father and mother,

Who are resting in the valley;

When the gods witness your action

They will say: 'Accepted' […][6]

Not only do we have here a description of how to behave when close to the divine, but if we bear in mind that piety and devotion did not play a significant role (being almost absent) in the older instruction texts such as the 'Instruction of Ptahhotep' or the 'Instruction for Merikare', both dated to the Middle Kingdom, we can better understand the significance of New Kingdom instructions.

Furthermore, among the usual topics covered by such prayers, the workman Qenherkhopshef, who lived in Deir el-Medina during the 20th Dynasty, emphasizes on his stela (stela BM 278)[7], his particular closeness to the goddess Hathor:

[…] I was born in your [Hathor's] precinct,

[…] I ate from the offering loaves of the lector priests beside the great akh-spirits.

I walked about in the Place of Perfection,

I spent the night in your precinct,

Drinking water which flowed from the mountain

In the precinct of Menet;

It waters the rushes and the lotuses for you,

In the precinct of Ptah.

My body spent the night in the shadow of your [Ptah's] face,

I slept in your precinct,

I made stelae in the temple beside the lords of Djeseret […][8]

Spending the night in the precinct of a god is technically known as 'incubation' and is well attested in Greco-Roman times. It was a way of experiencing the divine, but was done to heal illnesses or sufferings in general. In such circumstances gods could also appear to people in dreams. The Egyptian 'dream book', a text also composed in Deir el-Medina and dated to the New Kingdom, contains elaborate explanations to cover the possible meanings of this experience.[9] In another text, a biographical inscription in tomb TT 409, Samut called Kyky, the assessor of cattle in the domain of Amun, declares that he felt so close to the goddess Mut

that he has chosen her as his sole patron in life and announces his intention to bequeath all his property to her temple at Karnak.[10] Other examples contain proper prayers, such as that on the private stela of the guard Penbuy at Deir el-Medina, who begs the goddess Taweret to let him have children.[11] Monuments of this kind consist of a written part – the prayer – and an iconic section, in which the donor is represented adoring or making offerings to the deity named in the texts. The donor usually faces the divine figure, although he never touches it. It is the visual representation of a ritual act that enacted a closeness to the divine without the mediation of ritual experts (i.e. priests). It is difficult to reconstruct the ritual performed, but it seems that it took place in front of the community in the shrine area. It is difficult to say whether the donors shown, whose titles do not always define them as priests, faced the divine figure represented or not. What they certainly display, however, is a belief in a closeness to the divine that can be achieved at least through ritual actions. Moreover, the combination with a prayer suggests the idea of a framework by which a personal approach to the divine was possible.

Neighbourhood Gods

The deities chosen by devotees were primarily the city gods believed to inhabit the local shrine or temple. That is why devotional stelae usually depict local deities and the accompanying prayer is normally dedicated to the local god, as was the case, for example, with Neferabu's stela to Ptah, who was venerated in a local shrine at Deir el-Medina. Most devotional stelae from Memphis, therefore, tend to show the locally venerated god Ptah rather than such gods as Khons, Amun and Mut, while stelae from Asyut have the jackal god Upuaut, from Deir el-Bahri the cow goddess Hathor and from Deir el-Medina the snake goddess Meretseger. The reason for this is to be seen in the fact that city or local gods were physically approachable and therefore closer than any other god, no matter how important he was within the Egyptian pantheon. Beside the local gods, the closest gods were considered those related to one's profession. As such these were the object of a particular devotion from at least the Middle Kingdom.[12] An example of a god related to one's profession comes in a series of prayers composed by scribes in the New Kingdom and dedicated to the god Thoth, since he was considered the patron of writing and scribes (figs. 49–51). There was also a category of deities with a particular relevance since they were considered as protecting or responsible for a certain situation in life: the goddess Taweret, for example, was the protector of pregnant women and those giving birth.

The importance of physical closeness to a god reached its peak in the New Kingdom and Late Period, when the practice of oracles, for which there is sporadic earlier evidence,[13] increased dramatically. During public festivals, for instance, the statues of the local gods were taken by priests from their shrine to be carried in procession in a sacred barque. The community participated in these events, which culminated in rich feasts that took on both a sacred and

profane character. People were able to approach the barque and offer up personal requests that were mediated by the priests. The most famous of these festivals was the 'Beautiful Feast of the Valley', which was held annually in Thebes during the New Kingdom. The Theban divine triad Amon, Mut and Khons were taken in procession from the temple of Karnak (fig. 52) to the royal mortuary temples on the West bank of the River Nile. Reliefs and paintings display huge numbers of people crowding around the holy barques and exalting them. Another feast that certainly involved the inhabitants of a particular region was performed in Asyut in honour of Upuaut. About six hundred stelae found in the tomb of the Middle Kingdom nomarch Djefaihapy III, which was reused as a local shrine after the owner's death, display in different ways a religious procession or feast that celebrated the jackal god Upuaut with the presence of other jackals.[14] These devotional stelae are similar to those from Deir el-Medina in their general composition of text and image and in their purpose. Although no examples of prayers like Neferabu's are documented, they shed light on the religious beliefs and practices related to Asyut: unlike in Deir el-Medina or Memphis, for example, relatively high numbers of women are recorded as unique donors of stelae, either simply described as responsible for a household or in the role of cultic 'chantresses', and this particularly enlightens issues regarding the relationship between religion, gender and class in ancient Egypt.[15]

Top
54. Wooden cramp of King Seti I, 19th Dynasty, perhaps from his mortuary temple at Thebes, *Myers Collection at Eton College, ECM 1597*. The use of wooden cramps (dovetails) to connect two blocks of stone in architecture is known from the Old Kingdom until Roman times. If not made of wood, dovetails have been found in lead, copper and also in stone. Since it seems unlikely that wooden dovetails were thought to be sufficiently strong to prevent a wall from settling or bulging, it has been suggested that wooden cramps were used to hold two blocks together while the mortar was drying.

Above
55. Wooden cramp of King Seti I, 19th Dynasty, probably from Abydos, *Myers Collection at Eton College, ECM 1830*.

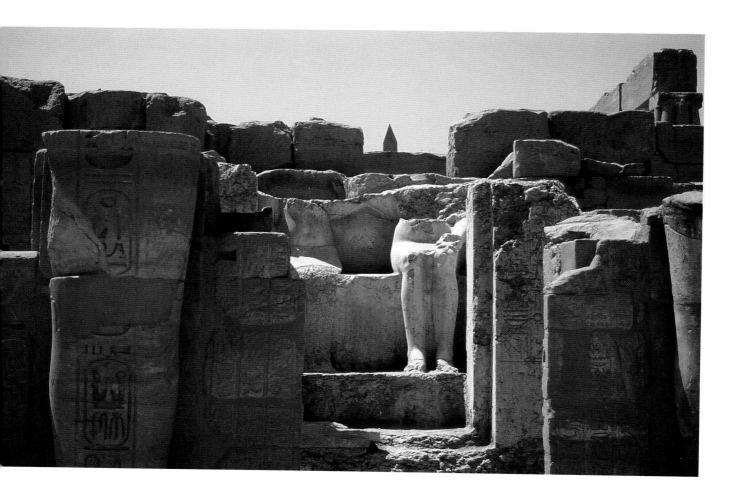

Approaching the Divine in Cult and Ritual

According to Egyptian religious thought there were different dimensions in which man could be close to the divine: the cult, the cosmos, the myth and personal piety.[16] When looking for physical evidence of religion and religious practice, however, archaeologists base their research on several indicators of ritual and cult, such as religious imagery or material in a defined religious context.[17] Thus, closeness to the divine can be proven archaeologically only in cult contexts or those that can be related to personal piety, considering piety in the broad sense, that we have adopted so far, as not only the religious belief but also the religious practices connected with it.

Closeness to the divine in cult is first encountered in the funerary cult, as a glorified deceased was believed to become an Osiris and to meet the gods once in the Afterlife.[18] Secondly it is found in the ritual actions performed in a shrine. This might be a local shrine,

such as one dedicated to Ptah and Meretseger in Deir el-Medina (fig. 53), or within the parts of a divine temple enclosure (figs. 54 and 55) to which commoners were sometimes admitted, either for the performance of the state cult (though this would have been barred to ordinary people) or for personal religious practices. We shall concentrate on this second aspect. Evidence for the religious practices of common people in and around temple enclosures can only be demonstrated through architecture when they led to the construction of shrines and prayer places, for example in the case of the shrine of the 'Hearing Ear' at Karnak (fig. 56), built under Thutmosis III (18th Dynasty). In addition, a few types of archaeological remnants, such as votive offerings or intermediary statues,[19] as well as written sources (mostly private letters), shed light on the religious practices performed to approach the divine. Private correspondence, mostly dated to the Late Ramessid Period, is of particular interest as it shows the way common people would address questions related to their personal life to a priest

This page

57. Faience sistrum with the face of Hathor, 22nd Dynasty or later, 24 × 6 × 2.5 CM., *Myers Collection at Eton College, ECM 1693.* The sistrum was a cult instrument that, when shaken, produced a sound suggesting that made by the Hathor cow pushing through the marshes (the sound-producing crossbars and beads are unfortunately missing). The sistrum is surmounted by the goddess Ma'at wearing a feather on her head, facing a male and female ba bird, both wearing sun-discs.

involved in the cult of a deity (ideally the local god), in order to get a divine response. In a letter dated to the 20th Dynasty, for instance, a certain Amenophis replied to an earlier letter from a certain Thutmosis, saying that he put 'him' in front of (the statue of) Amenophis I, who was venerated post-mortem in Deir el-Medina. This probably means that Amenophis, who is identified as a high priest of Amenophis I in Western Thebes, presented a stela donated by Thutmosis, thus transmitting his prayers. Furthermore, due to his profession as a priest, he was able to report to Thutmosis the alleged answer of Amenophis I, who assured him that he would bring him back home safely:

> […] I am submitting your case before [the oracle of] Amenophis, l.p.h., whenever he appears in procession.
> 'I will protect you; I will bring you back safe […]'
> So he keeps responding.[20]

Other letters mention, for example, the practice of making libations of water while offering to a deity. In addition, approaching the divine in cult is proven by various types of votive objects, of which the most famous are the votive offerings found in numerous temples dedicated

Opposite page, top left
58. Faience chalice in the form of a blue lotus, 18th Dynasty, 13.5 × 8.5 × 8.5 CM., *Myers Collection at Eton College, ECM 1578.* Lotus chalices, which first appeared during the 18th Dynasty, are to be distinguished into two basic forms: those imitating the shape of a narrower blue lotus (*Nymphaea caerulea*) and those depicting the broader white lotus (*Nymphaea lotus*). Similar to the blue faience bowls, lotus chalices were used as votive offerings in temples as well as containers for funerary offerings.

Opposite page, top right
59. Faience chalice in the form of a white lotus, 18th Dynasty, 10 × 10 × 11 CM., *Myers Collection at Eton College, ECM 1579.*

Opposite page, bottom left
60. Faience chalice in the form of a white lotus, Third Intermediate Period, 9.5 × 9.5 × 8 CM., *Myers Collection at Eton College, ECM 1581.*

Opposite page, bottom right
61. Faience chalice in the form of a blue lotus, Third Intermediate Period, 13.5 × 8.5 × 9 CM., *Myers Collection at Eton College, ECM 1676.*

Below
62. Faience basket with lid, New Kingdom or later, probably from Tuna el-Gebel, 11 × 9 × 7 CM., *Myers Collection at Eton College, ECM 845.*

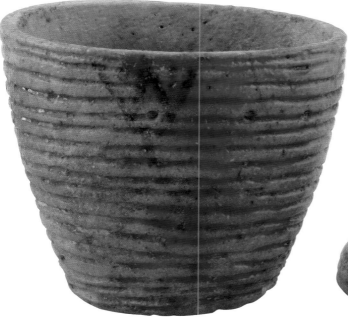
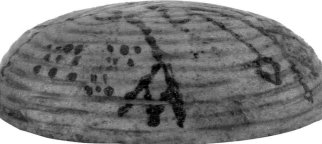

Opposite

63. Façade of a round-topped stela, height 29.5 CM., 18th Dynasty. *Myers Collection at Eton College, ECM 1888.*

to the cult of the goddess Hathor (fig. 57).[21] Several objects from the Myers collection are especially useful in relation to this particular topic. The function of the various chalices made of fine blue faience (figs. 58–61) is not entirely clear. They may have been used for different purposes, like the faience bowls found in large quantities at Deir el-Bahri, where they were clearly part of the cult of Hathor,[22] although a role in the funerary cult cannot be completely excluded.[23] Similar to these bowls there are also such objects as the faience basket bearing a floral decoration (fig. 62). On the other hand, an object that is not included in the exhibition deserves special attention. It was probably the façade of a wooden round-topped stela, erected in Deir el-Bahri (fig. 63). It bears the names of queen Hatshepsut and her husband king Thutmosis II (18th Dynasty) and was probably donated by a high official under Hatshepsut who had previously served during Thutmosis II's reign and remained a devotee of him.[24] Unfortunately, the original stela has not yet been identified and therefore its content cannot be exactly identified. What is relevant here is the fact that the façade's small size, its general appearance and the material used (wood), as well as comparison with similar monuments from Ramessid Egypt, seem to suggest that its intended purpose was for private use linked to the cult of Hathor in Deir el-Bahri.[25]

Sacred and Divine in Everyday Life

As we have seen, the gods were believed to intervene in one's everyday life. Their manifestation was seen in cases of illness or misfortune, but also in career advances, recovery from severe illness and being rescued from dangerous situations. Profane and sacred spaces were separated in everyday life. Thus, the creation of sacred spaces was necessary to enable the manifestation of the divine and to interact with it. This is witnessed by the construction within houses of sacred immobile infrastructures such as altars or sacred niches, sometimes painted with sacred imagery, as well as by various types of mobile remnants that were kept at home, like stelae. These indicate the will to perform ritual actions for private purposes in a private environment. The greatest quantity of material of this type dates to the New Kingdom and comes mostly from Tell el-Amarna or Deir el-Medina. Archaeological excavations undertaken in order to reconstruct forms and ways of personal religious practice performed within the household have indeed proved the existence of an active and developed private religious practice.[26] However, these two settlements cannot be considered as typical of domestic religious practices in Egypt as a whole. Tell el-Amarna and Deir el-Medina, both founded in the 18th Dynasty, are isolated cases in Egyptian culture, as they were built purposely by royal command.[27] Tell el-Amarna in Middle Egypt was built by Akhenaten as a new capital to sustain his religious reform and Deir el-Medina on the West bank of Luxor was founded, probably by Amenophis I, as a village for the workers, scribes and artisans involved in the building and decoration of the royal tombs of the New Kingdom in the Valley of the Kings. This means that life in these two settlements was strongly influenced by royal administration and official religion, and so

Top, left
64. Amulet of Isis and Harpocrates, 22nd Dynasty, 6 × 3 × 1.5 CM., *Myers Collection at Eton College, ECM 1532.* (See also fig. 18)

Top, centre
65. Amulet of a lion-goddess. Third Intermediate Period, 10 × 4 × 2.5 CM., *Myers Collection at Eton College, ECM 1663.*

Top, right
66. Amulet of Sakhmet. Late Period, 9.5 × 3 × 3 CM., *Myers Collection at Eton College, ECM 1716.*

Bottom, left
67. Amulet of a model decree case of the goddess Mut, 22nd Dynasty, 4.5 × 1 × 1 CM., *Myers Collection at Eton College, ECM 1665.* Uttered by the goddess Mut and recorded on papyrus, oracles were sometimes kept in family archives. This model case is quite likely to resemble the shape of otherwise larger decree cases as kept at home to preserve the divine oracle. Worn around the neck, this amulet refers most probably to the protection received through the goddess by such an decree.

Bottom, centre
68. Amulet representing the goddess Mut wearing the Double Crown, 22nd Dynasty, 5 × 1 × 0.5 CM., *Myers Collection at Eton College, ECM 1664.*

Bottom, right
69. Amulet representing the goddess Mut wearing the Double Crown, 22nd Dynasty, 10 × 3 × 2.5 CM., *Myers Collection at Eton College, ECM 1689.*

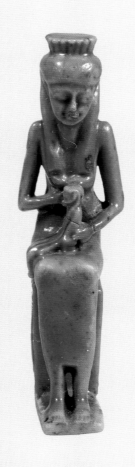
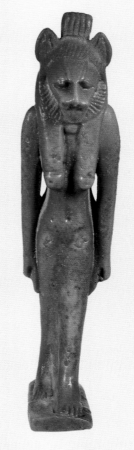
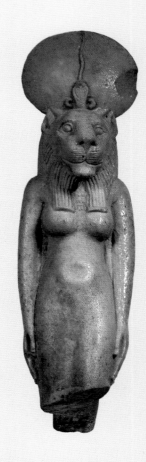

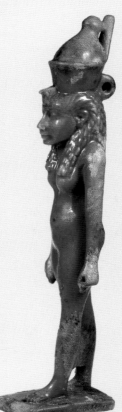

the reconstruction of spontaneous religious beliefs and practices of everyday life that might stand for Egyptian private religion in general is not entirely possible. Bearing this in mind, both Tell el-Amarna and Deir el-Medina display in various ways private religious practices mostly centred on beliefs around pregnancy and childbirth, and cults involving ancestors and local deities, such as the snake goddess Meretseger at Deir el-Medina and the royal family (as mediator to the unique god Aton) at Tell el-Amarna. Moreover, a couple of letters from Tell el-Amarna display for the first time the letter formula, well known from later times, in which the sender declares that he 'speaks' (i.e. prays) every day to a god,[28] whom he (or she) asks to give health to the receiver of the letter:

> […] How are you? Are you all right? I'm all right. Now here am I calling upon the Aton, l.p.h., in the city of Akhetaton, l.p.h., to keep you healthy each day […].[29]

It seems then that people were also looking for a direct contact to the divine for matters of everyday life at a time when the official mediator between people and god was Akhenaten himself.[30]

In examining the everyday search for sacred and divine, another aspect that has to be taken into account is magic, although Egyptologists tend to separate religion from magic. The main question, however, is whether magic was also part of this personal approach to the sacred and the divine. An attempt to illustrate the answer to this question may come from amulets representing, for example, Isis and Harpocrates (fig. 64), or a lion-goddess (figs. 65 and 66), or human figures in various forms (figs. 67–69). We shall concentrate on an amulet representing Bes (fig. 70). Bes was a god, or perhaps more accurately a demon, who looked like a dwarf with short legs and a wide face. His generally ugly features were part of his apotropaic power: he was believed to protect against illnesses and evil, and thus his protection was often invoked at night to fight against demons who could attack an individual while asleep, during pregnancy and, most of all, in childbirth. Amulets have been found mostly in tombs, but in life they were probably worn when the protection of a specific god was particularly relevant. Magic was regularly applied to solve everyday problems, such as illness or love troubles. Through a magical rite the individual came close to the sacred superhuman sphere for as long as the spell and the magical rite lasted. In other words, we can consider magic as a form of precisely applied action with a religious background, without necessarily involving piety. Ordinary people, however, probably thought of it as a way of achieving closeness to superhuman agencies, although unlike that they looked for in temples or at home in front of altars.

Nonetheless, the relevance of an amulet should be distinguished from the significance of such objects as a dish with a handle in the form of a female musician (fig. 71) or a bronze mirror (fig. 72). Mirrors of this type, with a flat, slightly oval disc representing the sun, and

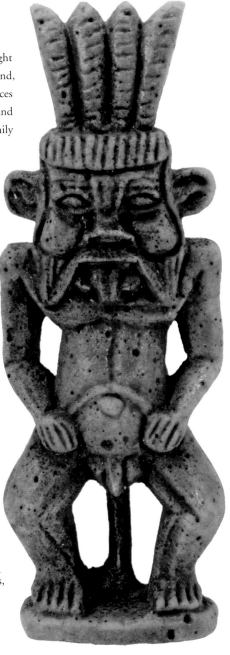

Above
70. Amulet of Bes. Late Period. *ECM 1540* (not in exhibition). From *Azules Egipcios: Pequeños tesoros del Arte* (Madrid, 2005).

Above

71. Cosmetic spoon with a handle in form of a female musician, steatite, 18th Dynasty, 10 × 7.5 × 2 CM., *Myers Collection at Eton College, ECM 1793*. The handle of this dish depicts a sparsely clad female lute player in the papyrus marshes. This is a well-known genre in Egyptian art, emblematizing what the Egyptians referred to as 'making oneself a happy day'. In depicting what would have been a favourite pastime of the leisure class, this luxurious spoon can also be identified as belonging to a household of the elite.

Right

72. Bronze mirror with a maiden handle, 18th Dynasty, 19.5 × 11 × 1.5 CM., *Myers Collection at Eton College, ECM 1788*.

the handle in the form of a standing naked female figure with a papyrus umbel above her head, are very common in Egypt during the New Kingdom. The female figure is considered as an alternative to the figure of the goddess Hathor that appears on the handle of mirrors in the Middle Kingdom, and bore an erotic significance connected with love and fertility. Mirrors are found both in tombs, where they assume the significance of rebirth and regeneration, and in settlements. They illustrate how the original religious elements associated with an everyday object, such as a mirror, turn into secondary meanings when partly reduced to decorative purposes. On the contrary, although finger rings with divine figures (figs. 73 and 74) are known almost only from burial contexts, we cannot exclude the possibility that they were also worn in life. More difficult is the correct identification of the original context of a necklace such as that illustrated here (fig. 75), since necklaces have been found in everyday contexts, as part of funerary equipment and among other votive offerings. All this should be taken as an indication of the blurred boundary between sacred and profane in ancient Egyptian

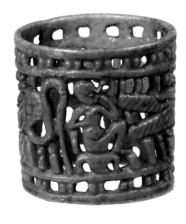

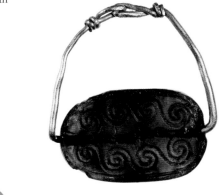

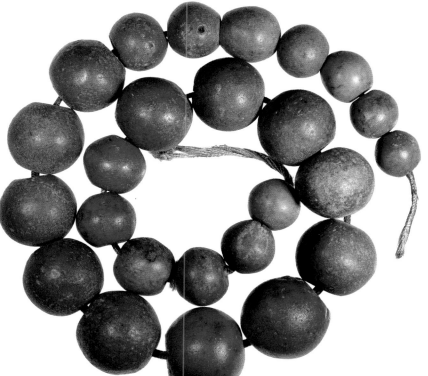

Top
73. Finger ring with Harpokrates. Third Intermediate Period, probably from Tuna el-Gebel, 3 × 3 × 3 CM., *Myers Collection at Eton College, ECM 1482.*

Above
74. Wire finger ring with a scarab, gold and amethyst, 12th Dynasty, 3 × 3 × 1 CM., *Myers Collection at Eton College, ECM 1846.* The ornamental pattern of this scarab's underside allowed for sealing documents and containers but do not reveal the bearer's name.

Left
75. String of spherical faience beads, unknown date, 42 × 2.5 × 2.5 CM., *Myers Collection at Eton College, ECM 1853.*

Top
76. Faience vessel in the form of a fish, 18th
Dynasty, 12 × 5.5 × 2.5 CM., *Myers Collection at
Eton College, ECM 1785.* Vessels in the shape
of a fish, mostly the tilapia, evoke the concept
of regeneration and fertility and were used as
containers of precious oil in elite households.

Below, clockwise from left
77. Figure of the Horus falcon. Late Period.
7 × 4.5 × 0.5 CM., *Myers Collection at Eton
College, ECM 1530.*

78. Thoth as an ibis holding the feather of
Ma'at. Bronze and calcite. Late Period.
3 × 4 × 1 CM., *Myers Collection at Eton College,
ECM 1691.*

79. Thoth as an ibis holding the feather of
Ma'at. Bronze and calcite. Late Period.
12 × 5.5 × 2.5 CM., *Myers Collection at Eton
College, ECM 1692.*

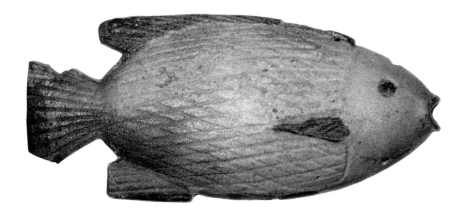

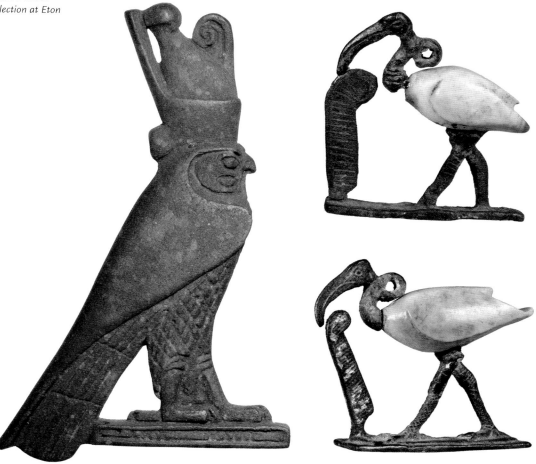

Left
80. Thoth as a baboon holding an Udjat-eye. Late Period. 4.5 × 3 × 2 CM., *Myers Collection at Eton College, ECM 1718.*

Below
81. Cosmetic spoon in the form of an oryx, 18th Dynasty, 11 × 6 × 1.5 CM., *Myers Collection at Eton College, ECM 799* (see also fig. 71). The oryx, representing Seth and giving to this cosmetic spoon its shape, stands for the disorder that can be controlled and turned into order, simply by binding his legs. Unable to move, Seth could cause no danger for the person who used this spoon during her daily life. Since this artefact most probably comes from a funerary context, it is evident that this concept was also favoured by those who wanted to exclude any dangers immanent in figures of Seth.

everyday life, at least in as much as we can reconstruct it under the influence of a modern viewpoint. Lastly, mention should be made of the adoration of animals (animal cult). This practice flourished in the first millennium BC and led to the creation of huge cemeteries for mummified animals, the most famous one being the Serapeum (the cemetery of the Apis bulls) at Saqqara, close to modern Cairo. The figure of a fish shown here (fig. 76) might be related to this phenomenon, although its precise meaning is difficult to determine.

Archaeological material and written sources suggest the search for closeness to the sacred and divine in ancient Egypt. People used various ways to approach a god, depending on factors such as their social status, the level of literacy, where they lived and the environment. Ordinary people without training would certainly not know the theological meanings behind

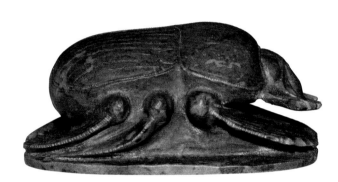

Above, left

82. Faience pectoral showing a woman in adoration before Banebdjedet and Hatmehyt, Third Intermediate Period or later, 11 × 10 × 1 CM., *Myers Collection at Eton College, ECM 1686*. Although this pectoral represents a complex local myth including divinities from Mendes, the 'hieroglyphs' attached to it and supposed to identify the figures depicted are meaningless, most probably due to the small size of the object.

Above, right

83. Scarab, Late Period, 6 × 4 × 3 CM., *Myers Collection at Eton College, ECM 1713*. Since the underside of this scarab is left blank, the exact meaning of this object is difficult to determine, although its function as an amulet representing the wish for regeneration is certainly implied.

the complex divine iconography of the Horus falcon (fig. 77), or of the god Thoth as an ibis bird holding the feather of Ma'at (figs. 78 and 79), or of a baboon carrying an Udjat-eye (fig. 80) or of a bound antelope (fig. 81) as a metaphor for the evil god Seth deprived of his power. Such people also would not have been able to read and understand complex religious scenes similar to that displayed on a funerary pectoral (fig. 82). Nonetheless, letters tell us that gods were invoked every day. The sun-god, in particular, was cited as the object of invocation at sunrise and sunset, that is to say when he appeared (fig. 83) and disappeared. Whether this was really the case is a question that Egyptologists will never be able to answer. What can be done, however, is to give voice to those ancient invocations by trying to recognize and reconstruct *where* and *when* men and women in ancient Egypt left the Profane to enter the Sacred.

Endnotes

1 Cf. M. Luiselli, 'Personal Piety (Modern Theories Related to)', in J. Dielemann and W. Wendrich, eds, UCLA Encyclopedia of Ancient Egypt (Los Angeles, 2008); http://escholarship.org/uc/item/49q0397q.

2 J. Baines, 'Restricted Knowledge, Hierarchy, and Decorum: Modern Perceptions and Ancient Institutions', *Journal of the American Research Center in Egypt*, XXVII (1990), pp. 1–24.

3 Stela British Museum 589: see T.G.H. James, ed., *Hieroglyphic Texts from Egyptian Stelae, etc.*, IX (London, 1970), p. 589, pl. 31.

4 Translation taken from E. Frood, *Biographical Texts from the Ramessid Period*, Writings from the Ancient World (Leiden and Boston, MA, 2007), p. 225.

5 D. Karl, 'Funktion und Bedeutung einer *weisen Frau* im alten Ägypten', *Studien zur Altägyptischen Kultur*, XXVIII (2000), pp. 131–60.

6 Translation taken from M. Lichtheim, *Ancient Egyptian Literature*, II: The New Kingdom (Berkeley, CA, 1976), p. 137.

7 Stela BM 278: P. Vernus, 'La déesse Hathor et la piété personnelle: la stèle de Qenherkhepeshef', in G. Andreu, ed., *Les artistes du Pharaon: Deir el-Medineh et la Vallée des Rois* (Paris, 2002), pp. 239–42.

8 Translation taken from Frood, *Biographical Texts from the Ramessid Period*, p. 230.

9 K. Szpakowska, *Behind Closed Eyes: Dreams & Nightmares in Ancient Egypt* (Swansea, 2003).

10 For an English translation of this text, cf. Frood, *Biographical Texts from the Ramessid Period*, no. IIA–B, pp. 84–91.

11 Stela of Penbuy, Kelvingrove Art Gallery and Museum, Glasgow: see M. L. Bierbrier and H.J.A. de Meulenaere, 'Hymne à Taouêret sur une stèle de Deir el-Médineh', in *Sundries in Honour of Torgny Säve-Söderbergh*, Acta Universitatis Upsaliensis, 13 (Uppsala, 1987), pp. 23–32.

12 B. Backes, 'Piété personnelle au Moyen Empire? À propos de la stèle de Nebpou (Ny Carlsberg ÆIN 1540)', *Bulletin de la Société d'Egyptologie de Génève*, XXIV (2001), pp. 5–9.

13 See J. Baines and R. B. Parkinson, 'An Old Kingdom Record of an Oracle? Sinai Inscription 13', in J. Van Dijk, ed., *Essays on Ancient Egypt in Honour of Herman Te Velde* (Groningen, 1997), pp. 9–27.

14 Cf. T. DuQuesne, 'Empowering the Divine Standard: an Unusual Motif on the Salakhana Stelae', *Discussion in Egyptology*, 58 (2004), pp. 29–56.

15 T. DuQuesne, 'Gender, Class, and Devotion: Demographic and Social Aspects of the Salakhana Stelae', *Discussion in Egyptology*, 63 (2005), pp. 41–57.

16 J. Assmann, *Ägypten: Theologie und Frömmigkeit einer frühen Hochkultur* (Stuttgart, 1984), pp. 16ff.

17 For a complete list of these indicators, see A. Stevens, *Private Religion at Amarna: The Material Evidence*, BAR International Series 1587 (Oxford, 2006), p. 22.

18 Cf. the article by Martin Bommas in this volume.

19 See, for instance, G. Pinch, *Votive Offerings to Hathor* (Oxford, 1993), pl. 40.

20 British Museum, P. BM EA 10417: E. F. Wente, *Letters from Ancient Egypt* (Atlanta, 1990), no. 296, p. 179.

21 G. Pinch, *Votive Offerings to Hathor* (Oxford, 1993).

22 Ibid., esp. pp. 308–15.

23 Cf. the article by Martin Bommas in this volume.

24 Cf. N. Reeves and S. Quirke, in S. Spurr, ed., *Egyptian Art at Eton College: Selections from the Myers Museum*, exh. cat., Metropolitan Museum of Art, New York, and Eton College (New York, 1999), p. 23, where it is suggested, however, that the donor was also a devotee of Hatshepsut.

25 See *Azules egipcios, pequeños tesoros del Arte*, exh. cat., Instituto de Estudios del Antiguo Egipto, Madrid (Madrid, 2005), p. 106, as well as N. Reeves and S. Quirke in S. Spurr, ed., *Egyptian Art at Eton College*, p. 23, who recognize the area on the south side of Hatshepsut's temple, adjacent to the southern shrine of Hathor, as the original place where the stela came from. For this particular shrine, cf. Pinch, *Votive Offerings to Hathor*, pp. 7–9.

26 A. Stevens, 'The Material Evidence for Domestic Religion at Amarna and Preliminary Remarks on its Interpretation', *Journal of Egyptian Archaeology*, LXXXIX (2003), pp. 143–68; Stevens, *Private Religion at Amarna*.

27 For this topic see especially B. Kemp, 'How Religious were the Ancient Egyptians?', *Cambridge Archaeological Journal*, V (1995), pp. 25–54.

28 These formulas are attested already in Late Middle Kingdom letters, in which the sender declares that he speaks to the king (Amenophis III), who has to be considered as a god. The letters from Tell el-Amarna, however, are the first in which a deity (and not the king) is called upon.

29 P. Robert Mond 1: E. F. Wente, *Letters from Ancient Egypt*, no. 123, p. 94.

30 S. Bickel, '"Ich spreche ständig zu Aton": Zur Mensch-Gott-Beziehung in der Amarna Religion', *Journal of Ancient Near Eastern Religions*, III (2003), pp. 23–45.

4

Papyri in Hellenistic and Roman Egypt

Michael Sharp

One of the most fascinating legacies of ancient Egypt is the wealth of texts that have survived from all periods of its history. There are of course the numerous inscriptions in stone on the temples, tombs and coffins familiar to every visitor to the country or to museum collections. Texts also survive written on other materials, such as wood, parchment and broken pieces of pottery (called ostraca). Of special importance for the history of ancient Egypt are texts written on papyrus (referred to as papyri). Apart from the Books of the Dead (which are discussed in Chapter 2), three such texts are included in the Myers collection, all written in Greek and dating to the Roman period of the first few centuries AD. This chapter will try to help the reader understand these texts by looking at the nature of papyri, the types of texts that survive and the contexts within which to approach the three particular specimens in the collection.

The papyrus plant is cultivated in only a few places in modern Egypt with the sole purpose of supplying the tourist market. In antiquity it grew over a much wider area, and it would have been particularly common in the marshes of the Nile Delta. Indeed, the hieroglyphic name for Lower Egypt could be written as several papyrus plants growing out of the sign for 'land'. The harvested papyrus stems had numerous uses, such as for ropemaking and, at least in the Pharaonic period, boat construction, but it is the production of a writing material that concerns us here. The triangular stalk of the papyrus was peeled, then cut into sections and divided into thin strips; each sheet consisted of two layers of strips, one layer placed vertically, one horizontally on top of the other. These were then beaten so that the pith could act as a natural glue to bind the strips together. After drying, the individual sheets of papyrus could then be glued together to form a roll, which usually consisted of twenty such sheets. The inner surface where the papyrus fibres ran horizontally, which was called the recto, was used for writing, while the verso, where the fibres ran vertically, was often left blank. The cost of papyrus, however, meant that it was sometimes reused when an earlier text was no longer required, in which case the new writing appeared on the verso. Indeed, we even have examples of literary texts being written on the backs of discarded documents, and occasionally vice versa. Another kind of reuse was in the production of cartonnage for mummies and some of our most important finds of papyrus texts have resulted from unwrapping mummies.[1]

The Myers collection contains a good example of a scribe's palette from the Pharaonic period, with two shallow pots each containing a thin cake of solid ink (one of which was red ink) and a case in which to keep the reed brushes, which would have been dipped in water before being applied to the ink (fig. 84). The reed brush gave way to a reed pen in the Greco-Roman period and the main ink used in this period was made from soot with a little gum arabic suspended in water, and had the advantage of not fading. During the second and third centuries AD metallic inks made an appearance, but these turn from black to brown with time and may indeed fade to almost the same shade of brown as the papyrus and become very difficult to read.'

84. A scribe's palette from the Pharaonic period, *ECM 1613*.

Although papyri have been found outside Egypt, such as at Herculaneum on the Bay of Naples and Petra in present-day Jordan, and we know that papyrus was used as a writing material as far away as Rome, nevertheless the great majority of known papyri come from Egypt itself. Indeed, a little over two-thirds of all published texts in Greek and Latin from Egypt were written on papyrus, amounting to more than forty thousand items, and papyrus remained a significant medium for the writing of Coptic, the later manifestation of the Egyptian language. Papyri have not, however, been found uniformly across Egypt. Almost all of those dating to the Greco-Roman period come from the oases of the Western Desert, a handful of sites in Middle Egypt, and a small number of villages on the edge of the Faiyum, a depression to the west of the Nile valley fed by a natural offshoot of the Nile called the

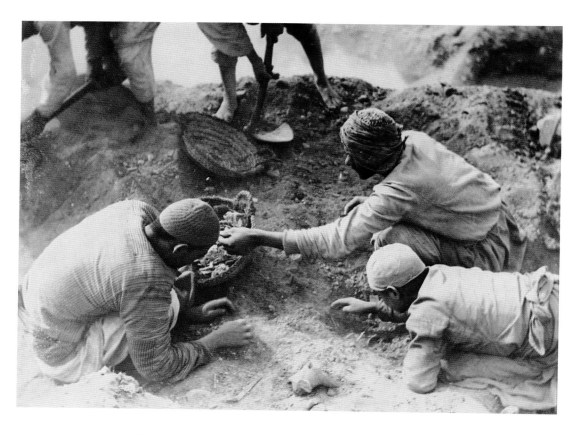

Above
85. Excavating the site of Oxyrhynchus in
c.1903. Photograph taken by A.S. Hunt
probably during the second season of
excavations.
*By kind permission of The Egypt Exploration
Society, London, and the University of Oxford
Imaging Papyri Project.*

Bahr Yusuf. Other parts of Egypt have yielded quantities of texts in other forms; ostraca, for example, are particularly abundant from sites in the Upper Nile valley from present-day Luxor south to Aswan and from quarry sites and military outposts in the Eastern Desert. Nevertheless, it remains the case that textual evidence from Egypt is very patchy and that there are many parts of the country from which little or nothing has been found.

The three papyri in the Myers collection all come from Oxyrhynchus, a city in a particularly wide section of the Middle Nile valley named after the 'sharp-nosed' fish that was its local deity. They were dug out of ancient rubbish mounds surrounding the small village of el-Behnasa during the years between 1896 and 1907 (fig. 85) by two young Oxford classicists, Bernard Grenfell and Arthur Hunt, whose work was supported by the then Egypt Exploration Fund, which subsequently gave these pieces to Eton College in return for its donations. Grenfell and Hunt were looking in particular for lost works of Greek literature and early Christian texts, and many notable discoveries were made in this area, such as a previously unknown play by Sophocles and a work called *The Sayings of Jesus*. About 90 per cent of their finds, however, consisted of documents produced in the course of the everyday lives of the city's inhabitants and subsequently discarded. The three texts in the Myers collection all belong to this category.[2]

All are written in Greek, which was introduced across Egypt with its conquest by Alexander the Great in 332 BC and its rule by his successors, the Ptolemies. It was the main language of royal administration and the elite, which included many descendants of the original settlers from Greece and Macedonia. The Egyptian language continued to be spoken widely and to be written using the Demotic script, particularly in the context of the traditional temples. During the Roman period of roughly the first three centuries AD, however, texts in Demotic almost completely disappear. It is only in late antiquity that the Egyptian language becomes visible again, this time in the form of Coptic, which was written in a modified version of the Greek alphabet and contained many Greek loan-words. Although Latin was used a good deal in the context of the Roman army in Egypt and would have been the language normally used among Roman magistrates operating in the province and in matters pertaining to Roman citizens, Greek remained the main language of the civil administration and of the elite under the Romans and their Byzantine successors, and was only eclipsed by Arabic in the period after the Islamic conquest in the seventh century AD.

An ability to speak both Greek and Egyptian appears to have been quite common, both in the towns and in the countryside. At any rate, the documentary record does not indicate any significant problems of oral communication among the population. Moreover, the very fact that Coptic contains so many Greek loan-words, which must have been adopted over the preceding centuries, suggests that large parts of the Egyptian-speaking population had developed at least a reasonable familiarity with Greek. No doubt there continued to be large numbers of people, especially in the countryside, who were only able to speak Egyptian, but the apparent presence of so many bilinguals enabled them to communicate, when necessary, with those speaking Greek, especially landowners from the cities and their representatives and parts of the civil administration. Greek was, however, the language of the elite, not just the provincial elite based in Alexandria, but also the local elites in every town and city. These belonged to the gymnasial class, which was formally recognized by the Roman provincial administration through the granting of tax privileges. Its members emphasized their Greek cultural identity through their attachment to the institution of the gymnasium, which was a cultural centre and not just a place for exercise. Membership of this class was exclusive and depended on being able to prove one's descent through male relatives on both sides of the family from those registered in this class at some point early in the period of Roman rule; at Oxyrhynchus, for example, reference is made to a register drawn up in the reign of Emperor Vespasian (AD 69–79). The children of this elite class received a proper education in Greek language, literature and rhetoric and would have used Greek routinely in their everyday lives. Indeed many surviving papyri come from school contexts and show the sorts of reading and writing exercises that pupils had to perform (fig. 86).[3]

An oral knowledge of Greek is not, however, the same thing as being able to read and write the language. The papyri and other documents reveal a society dependent on the written word, but this does not mean that literacy was widespread. It required a certain level of

Above
86. Papyrus written in the third century AD containing a *hypothesis* ('summary') and glossary for Book VII of Homer's *Iliad*, which was probably used in a school context (P.Oxy. XLIV 3159).
By kind permission of The Egypt Exploration Society, London, and the University of Oxford Imaging Papyri Project.

education and that required a certain level of wealth, yet the majority of the population would have been too preoccupied with ensuring basic subsistence to be able to afford to send its children to school. A complex picture emerges from the documents, however, for those sections of the population that did possess sufficient wealth but whose status was below that of the gymnasial class. Some were certainly proficient in reading and writing Greek, while others were completely illiterate. In between were what was probably a substantial number who possessed limited literacy and were able to sign their names, however slowly, or perhaps even to draft a simple document but no more. These propertied classes were periodically obliged to undertake liturgies, or compulsory offices in the local administration, most of which involved a considerable amount of record-keeping, and at least a basic level of literacy would have been helpful, if not essential, for them to be able to carry out their duties successfully. But all sections of the population would have been able to hire professional scribes when they needed documents to be drawn up, and the wealthier employed literate individuals on a longer-term basis in order to run their business affairs. Gender was also a factor in determining an individual's literacy. Among women outside the elite, it was probably very rare. It is also worth remembering that for much of the Roman period literacy in Greek was what effectively determined whether or not one was literate. Knowledge of the Demotic Egyptian script was always confined to a small group of scribes attached to the traditional temples, and even literacy in Coptic was for the first few centuries restricted mainly to clerical and monastic circles.[4]

The Myers collection contains two dice, dated to the Hellenistic or early Roman period, that contain a different Greek letter on each of their sides (fig. 87). There are, however, probably no implications for our understanding of literacy because the Greek alphabet was also used to represent the numbers.

Interestingly, being able to write Greek did not guarantee that one could use the language correctly. The Greek spoken in Egypt had developed considerably since the Greek of the Classical period of Greek history and was already showing some of the features of Modern Greek, both in phonology (the sounds of words) and in morphology and syntax (the grammar of the language). Classical Greek remained the model to which those writing any kind of text aspired, but its significant differences from the everyday Greek spoken around them not only meant that features of the contemporary language tended to creep in but also led to their making numerous mistakes in spelling and grammar. In particular, several vowels and diphthongs had come to be pronounced in the same way. We know this because the papyri frequently employ alternative spellings of the same word; most of these spellings are not correct in terms of morphology but clearly reflected current pronunciation.[5]

The Greek documents on papyrus fall into several categories. The largest was associated with the state and civic administration. Egypt was always one of the wealthiest parts of the ancient Mediterranean world owing to the fertility of its soil, refreshed by the annual Nile flood and fortified by the rich silt washed down from the Ethiopian highlands. Wheat was the most important crop, although barley was also cultivated widely for the brewing of beer,

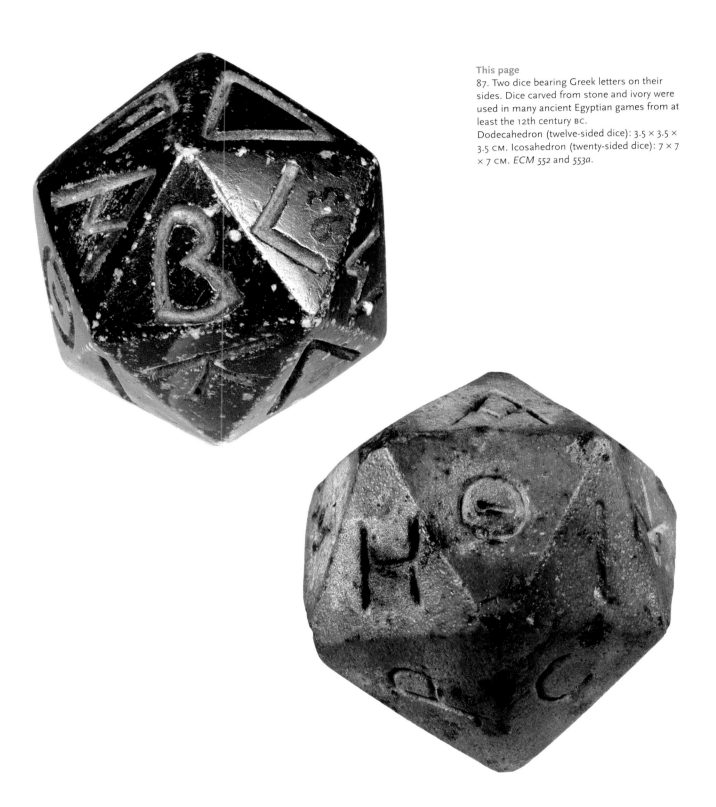

This page
87. Two dice bearing Greek letters on their sides. Dice carved from stone and ivory were used in many ancient Egyptian games from at least the 12th century BC.
Dodecahedron (twelve-sided dice): 3.5 × 3.5 × 3.5 CM. Icosahedron (twenty-sided dice): 7 × 7 × 7 CM. *ECM 552* and *553a*.

the main drink of the majority of the population. Taxes on arable land were largely paid in grain and the revenues thus acquired funded not just the court, government and army but also enabled Egypt's rulers to engage in diplomacy and wars overseas. Under Roman rule a significant portion of the wheat collected in tax was shipped to the city of Rome itself to be distributed free to its citizens as a monthly dole.

Unsurprisingly it was a major enterprise to organize the collection of tax-grain and move the produce received and numerous officials were involved at all levels. In order to assess the taxes to be levied, land registers needed to be compiled and kept up to date. When the grain was paid in tax, receipts needed to be given and records kept at the granaries. Accounts also needed to be kept of the quantities passed on to those shipping it to its destination. All this activity had to be supervised by officials at higher levels with all the resultant correspondence between them. Moreover, the importance of the annual Nile flood to the fertility of the soil and therefore to the size of the tax-yield meant that officials at all levels devoted much energy to ensuring the proper maintenance of the irrigation canals and dykes that enabled the flood water to be channelled to the fields where it was required.

The state did not, however, confine its activities to the collection of grain-taxes. Numerous other taxes and charges were levied, many of them in money from the Ptolemaic period on, and all required registers of eligible taxpayers, receipts, accounts of what was received, and correspondence as part of the process of supervision. One of the most important money taxes introduced by the Romans was a poll-tax called *laographia*, which was paid by all adult males other than those belonging to the privileged Greek cultural elite and the residents of Alexandria. In order to produce reasonably accurate registers of the population, a census was held every fourteen years in which each household had to make a written declaration of the names and ages of its members.[6]

Administering the law was naturally another major function of the state. This involved trying those accused of crimes but also adjudicating in civil disputes between individuals and organizations. When the prefect, or governor, of Egypt was holding his annual assizes in the main city of the Arsinoite nome (an administrative district in some ways akin to a modern country) in March AD 209, one document tells us that he received 1,804 petitions in the space of just over two days.[7]

Other areas of state activity that generated a great deal of documentation were the regulation of status, the regulation of the temples, the army and the maintenance of the peace. From the reign of Septimius Severus (AD 193–211) every nome-capital was allowed to run its affairs through a council elected from the local elite, and these generated their own voluminous documentation, including the minutes of their meetings. As well as liaising with the local provincial administration in matters of taxation, the councils concerned themselves with matters such as the construction and maintenance of public buildings, oversight of the local food supply and the markets, the provision of oil to the gymnasium and the occasional holding of games or shows.[8]

Opposite
88. Contract of employment relating to a vineyard, 19 × 12.2 CM., *Myers Collection at Eton College, ECM 1616; CHN 79.*

89. Letter from Eunoia requesting the redemption of her property, which had been pawned, 16.2 × 11.1 CM., *Myers Collection at Eton College, ECM 2197; CHN 76.*

Private individuals also generated documents, although most of them were produced by and for members of the wealthier sections of society whose affairs were usually more complicated. Many of these were of a legal nature. Whenever land or property was sold, leased or mortgaged, a contract would usually be drawn up between both parties, and numerous such sales, leases and mortgages survive. Marriage would generate a contract between both parties because property was at stake, and a deed of divorce would be drawn up if the marriage failed, while the transmission of property to others also often required a written document such as a will.

The first document in the Myers collection is cast in the form of a lease contract, or *misthosis*, but is actually a contract of employment (fig. 88).[9] It concerns a vineyard and neighbouring reed-plantation at the village of Talao in the north of the Oxyrhynchite nome. They belonged to Apion son of Horion, who was either a current or former gymnasiarch, that is the magistrate with responsibility for the gymnasium, which was the most prestigious post

Above
90. Invitation to dinner, 6.4 × 4.3 CM., *Myers Collection at Eton College, ECM 2314; CHN 72.*

available in the civic administration of the city at the time. The cultivation of vineyards had expanded considerably when the Greeks brought their tastes to Egypt under the Ptolemies, but they required considerable investment and resources, even though the profits could be impressive. Not only did the vines require careful tending throughout the year but they also required constant controlled irrigation, which could only be provided manually or with an animal-driven machine like a *saqia*, rather than relying on the Nile flood. Vineyards were usually associated with reed-plantations, where the vine-props were grown, and sometimes also contained orchards.

The 'lessee' was Amois son of Amois and Sambous, all Egyptian names, who was residing in Talao at the time. His contract was to last for one year, starting at the beginning of the Egyptian month Hathyr (in this case 28 October AD 188), so after the previous vintage was over. Although the papyrus is cut off at the bottom, enough survives to show that the 'lessee' was to undertake all the work involved in cultivating the reed-plantation and tending the

vineyard. It seems that he was to be present at the vintage but it is not clear what further tasks he may have had to undertake. Other similar lease contracts show that the 'lessee' could expect payment from the landowner, mainly in cash but also with an allowance of wheat and of the wine produced. Although Amois is not called an *ampelourgos*, the technical term for a skilled vine-dresser, we can assume that he was being employed for his skills. The landowner, however, would have retained full control of the land and of the wine produced.[10]

This vineyard will have formed just a small part of the total estate of Apion son of Horion, which, given our other evidence for large estates, would have spread throughout a large part of the Oxyrhynchite nome and may even have extended into neighbouring nomes. Although he probably employed managers to look after it, he almost certainly became involved in the large volume of correspondence and accounts that the running of such an estate would have generated, and indeed he may have contracted in person with Amois son of Amois and Sambous. A particularly good example of the management of a large private estate in the Faiyum in the third century AD belonging to the Alexandrian citizen Aurelius Appianus is documented in the voluminous archive of one of his managers, called Heroninos.[11]

The second document in the Myers collection is not itself of a legal nature but reflects the existence of legal arrangements to pawn some property made by or on behalf of the writer of the letter, a lady called Eunoia (fig. 89).[12] She is giving her correspondent instructions to redeem her property, which comprises an impressive list of clothes, including Dalmatian shawls the colour of frankincense and onyx, a handkerchief, two armlets, a necklace, two bracelets, a statue of Aphrodite, a cup and a wine-jar. The sheer list of luxury objects, and the fact that two of the garments contained the highly precious purple dye, indicates the sort of wealth at her disposal. Indeed, those pawned with a man called Sarapion were worth two hundred drachmas, which represented perhaps half a year's income or more for most people. Eunoia may have acquired these objects as part of her dowry. Why she needed to pawn them is open to speculation, although the fact that she was paying an interest rate of 48 per cent, four times the legal maximum on loans of money, suggests that she was unable to borrow the money she needed by other means. It may also account for the tone of urgency about her letter and her desire to redeem her property at all cost, even if her armlets had to be sold in the process. What the letter interestingly reveals is an elite woman, who possessed a high standard of literacy, playing an active part in managing her financial affairs and operating as part of a network of other women of similar status.

The final papyrus in the collection takes us into the realm of social and religious life (fig. 90).[13] It was sent by a man called Chairemon to an unknown recipient and asks him to dine the next day at the *kline* of the god Serapis in the Serapeum. This was the main temple in the centre of Oxyrhynchus, dedicated to an Egypto-Hellenic cult figure created by Ptolemy I in 286 BC, who was often equated by the Greek cultural population of Egypt with their supreme god Zeus. Temples often had dining-rooms attached to them and the gathering in this case was probably connected with the cult of the god, although the exact meaning of *kline* is

uncertain. We know of about a dozen other invitations to dinner that include this phrase, and three of them mention the Serapeum as the venue. Dinner was to begin at the ninth hour; the precise time cannot be known because hours were numbered from dawn and the time of this varied according to the seasons, but it will have been some time in the middle of the afternoon, probably around 3 pm, and was the usual time for such meals. Since both sender and recipient must have lived close by, it was possible to deliver the invitation in person and on the same day, but it is interesting that Chairemon gave so little notice of the dinner to his guest.[14] This, however, is true of the majority of the two dozen invitations known to us and suggests a rather different approach to planning one's social diary from today.

Endnotes

1 A good account of the production of papyrus as a writing material can be found in Adam Bülow-Jacobsen, 'Writing Materials in the Ancient World', in Roger S. Bagnall, ed., *The Oxford Handbook of Papyrology* (Oxford and New York, 2009), pp. 3–29. On the use of papyrus documents in the production of mummy cartonnage, see ibid., pp. 45–7. This practice seems to have been confined to the Ptolemaic period. One important find from this source is the second-century BC archive of the village scribe of Kerkeosiris in the southern Faiyum.

2 For an excellent recent introduction to Oxyrhynchus and its papyri, see Peter Parsons, *City of the Sharp-Nosed Fish: Greek Lives in Roman Egypt* (London, 2007). This can be supplemented by Alan K. Bowman et al., eds, *Oxyrhynchus: A City and its Texts* (London, 2007) and the excellent website http://www.papyrology.ox.ac.uk/POxy/.

3 For a good account of education in Egypt as attested by the papyri, see Raffaella Cribiore, *Gymnastics of the Mind: Greek Education in Hellenistic and Roman Egypt* (Princeton, NJ, 2001).

4 For a good discussion of literacy, see Roger S. Bagnall, *Egypt in Late Antiquity* (Princeton, NJ, 1993), pp. 230–60.

5 For a fuller discussion, see the useful chapter by Eleanor Dickey in Bagnall, *Oxford Handbook*, pp. 149–69.

6 A full account of the census and demographic analysis of the data to be obtained from the surviving census records can be found in Roger S. Bagnall and Bruce W. Frier, *The Demography of Roman Egypt* (Cambridge, 1994).

7 J. F. Oates, A. E. Samuel and C. B. Welles, *Yale Papyri in the Beinecke Rare Book and Manuscript Library* (New Haven, CT, and Toronto, 1967), I, no. 61.

8 See A. K. Bowman, *The Town Councils of Roman Egypt* (Toronto, 1971).

9 Published in *The Oxyrhynchus Papyri*, XIV, no. 1692.

10 For good analysis of this and related documents, see Jane Rowlandson, *Landowners and Tenants in Roman Egypt: The Social Relations of Agriculture in the Oxyrhynchite Nome* (Oxford, 1996), pp. 228–36.

11 Fully described and analysed in Dominic Rathbone, *Economic Rationalism and Rural Society in Third Century AD Egypt: The Heroninos Archive and the Appianus Estate* (Cambridge, 1991).

12 Published in *The Oxyrhynchus Papyri*, I, no. 114, reprinted in A. S. Hunt and C. C. Edgar, *Select Papyri* (Loeb Classical Library, published by Harvard University Press), I, no. 131, and republished in Jane Rowlandson, ed., *Women and Society in Greek and Roman Egypt: A Sourcebook* (Cambridge, 1998), no. 191, and Roger S. Bagnall and Raffaella Cribiore, *Women's Letters from Graeco-Roman Egypt* (Ann Arbor, MI, 2006), pp. 295–6.

13 Published in *The Oxyrhynchus Papyri*, I, no. 110.

14 For a fuller discussion of this type of document, see the introduction to *The Oxyrhynchus Papyri*, LII, no. 3693, and LXVI, no. 4540.

5

Economy and Art in Egypt from Alexander the Great to the Arab Conquest

Eurydice Georganteli

Egypt and the Ancient Greek World: Early Encounters

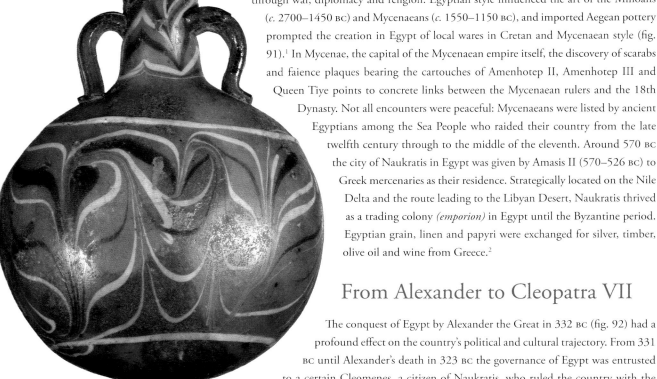

Egypt first met the ancient Greeks in the second millennium BC along trade routes and through war, diplomacy and religion. Egyptian style influenced the art of the Minoans (*c.* 2700–1450 BC) and Mycenaeans (*c.* 1550–1150 BC), and imported Aegean pottery prompted the creation in Egypt of local wares in Cretan and Mycenaean style (fig. 91).[1] In Mycenae, the capital of the Mycenaean empire itself, the discovery of scarabs and faience plaques bearing the cartouches of Amenhotep II, Amenhotep III and Queen Tiye points to concrete links between the Mycenaean rulers and the 18th Dynasty. Not all encounters were peaceful: Mycenaeans were listed by ancient Egyptians among the Sea People who raided their country from the late twelfth century through to the middle of the eleventh. Around 570 BC the city of Naukratis in Egypt was given by Amasis II (570–526 BC) to Greek mercenaries as their residence. Strategically located on the Nile Delta and the route leading to the Libyan Desert, Naukratis thrived as a trading colony *(emporion)* in Egypt until the Byzantine period. Egyptian grain, linen and papyri were exchanged for silver, timber, olive oil and wine from Greece.[2]

From Alexander to Cleopatra VII

The conquest of Egypt by Alexander the Great in 332 BC (fig. 92) had a profound effect on the country's political and cultural trajectory. From 331 BC until Alexander's death in 323 BC the governance of Egypt was entrusted to a certain Cleomenes, a citizen of Naukratis, who ruled the country with the title of satrap. Alexander's death plunged his vast empire into a deep crisis. Some of his former generals emerged as potential successors *(diadochoi)* and rulers for the various conquered areas. Ptolemy was one of them. He was appointed satrap of Egypt by general Perdiccas in 322 BC, to rule the country in the name of Philip Arrideos, Alexander's half-brother, and Alexander IV, Alexander's infant. Following a power struggle, Ptolemy finally assumed sole power in 305 BC under the title of Ptolemy I Soter (Saviour), king of Egypt, and founder of the Ptolemaic dynasty. His descendants ruled Egypt for almost 300 years until the death of the last Ptolemaic queen, Cleopatra VII, in 30 BC.[3] Among Ptolemy I's initial steps to legitimize his claim over Egypt were his efforts to secure the body of Alexander for Egypt, and to strike high-quality silver coins bearing images of the deified Alexander. On one of the first issues struck in the mint of Alexandria, Alexander appears on the obverse wearing an elephant scalp with trunks and tusks and a royal diadem (fig. 93). The inclusion in the headdress of the ram's horn of Zeus Ammon conveys Alexander's public persona as son of Zeus Ammon following

Above

91. Two-handled flask, New Kingdom, 18th Dynasty, *c.* 1350 BC. 10 × 7 × 4 CM., *Myers Collection at Eton College, ECM 1589.* This beautiful pale blue glass flask was modelled on imported Mycenaean flasks of precious oil.

Opposite

92. Bust of Alexander, Pentelic marble, 340–330 BC. Height 35 CM., *Acropolis Museum, Athens, no. 1331.*

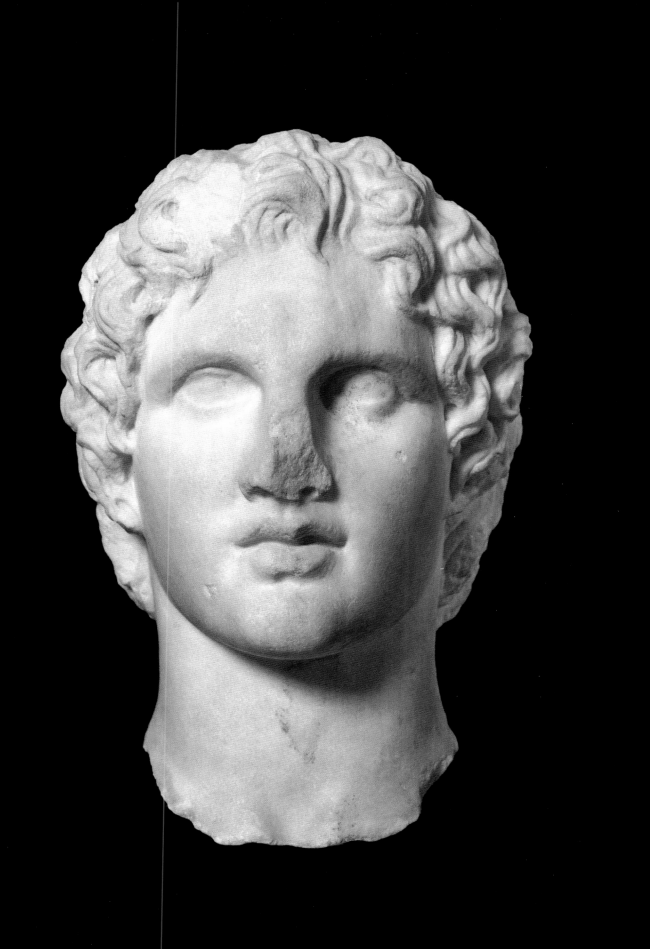

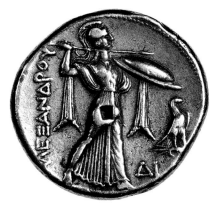

his visit to the oracle of Ammon in the Siwa desert. Reference to Alexander continues on the reverse of the coin with the inclusion of his name ALEXANDROU (of Alexander). It is only the image of an eagle on a thunderbolt, Ptolemy's personal badge, standing next to the goddess Athena, that hints at the identity of the real ruler of Egypt around 320/19 BC.[4] It was not until about 304 BC that Ptolemy struck gold staters in his own name. The obverse inscription identifies him as Ptolemy *Basileus* (King) and the accompanying iconography preserves the earliest realistic portrait of a Hellenistic ruler. The same degree of realism can be found in

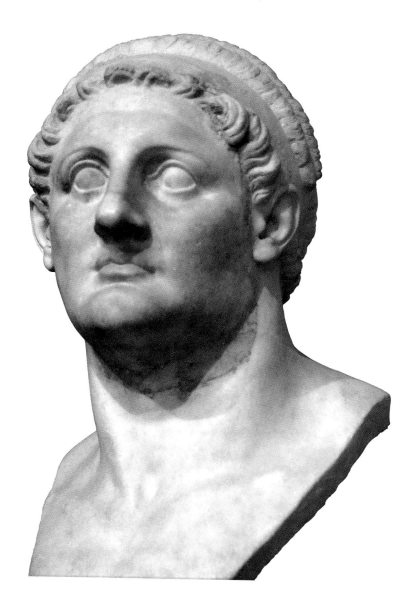

Above

93. Silver tetradrachm, struck under Ptolemy I, mint of Alexandria, 319–315 BC. Obverse: head of Alexander with the ram's horn and headband; Reverse: Athena standing. The vertical inscription in Greek refers to Alexander the Great. Test mark on both the obverse and reverse surface. Diameter 2.6 CM., *The Barber Institute Coin Collection, G13.*

Right

94. *Ptolemy I Soter*, marble, 3rd century BC, height 24 CM. *Musée du Louvre, Département des Antiquités Grecques, Etrusques et Romaines, Ma 849 (MR 457).*

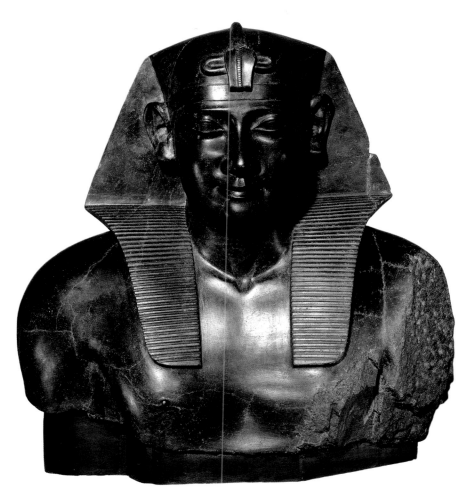

Left
95. *Ptolemy I Soter as Pharaoh*, basalt bust, 64 × 66 × 34 CM. The Egyptian *nemes* headdress and the *uraeus* worn by Ptolemy are indicative of his royal status. *British Museum, Department of Ancient Egypt and Sudan, 1914,0216.1.*

Below
96. Gold octadrachm of Ptolemy II Philadelphus, king of Egypt (*reg* 284–246 BC), struck in Alexandria. The reverse shows the deified portraits of Ptolemy I and Queen Berenice, as the accompanying inscription THEOI (gods) implies. The obverse is reserved for Ptolemy II and his queen and sister Arsinoe. The accompanying inscription PHILADELPHOI (brother- and sister-loving) refers to the Ptolemies' custom of marrying their siblings. Diameter 28 MM., weight 27.730 g. *British Museum, CM 1964-13-3-2.*

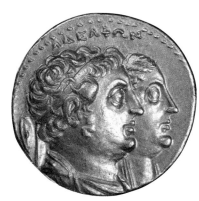

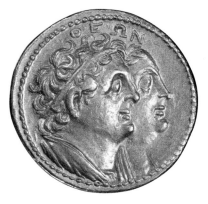

representations of Ptolemy in other artistic media, such as a marble bust in which he appears as a Hellenistic ruler (fig. 94), or a basalt bust that shows him as successor to the Egyptian Pharaohs (fig. 95). The desire of his descendants to present themselves as ideal Egyptian rulers extended to their marital arrangements. Ptolemy II adopted the Egyptian custom for the pharaohs to marry their sisters. His decision, which was considered incest in the ancient Greek world, was largely followed by the later Ptolemies and found its most explicit expression in the iconography and wording of his gold staters. While the reverse of his coins is reserved for Ptolemy II's deified parents, Ptolemy I and Berenice, the obverse shows Ptolemy II and his queen and sister Arsinoe (fig. 96). The accompanying inscription identifies the couple as PHILADELPHOI (brother- and sister-loving).[5] The Ptolemies adorned Egypt and its capital city Alexandria with new temples, palaces and places of learning. Among the latter the museum and library of Alexandria, both created by Ptolemy I, stand out. The museum was in effect the

Right, above
97. Denarius of Mark Antony, struck at a moving mint in the East in 32 BC. The head of Mark Antony with an Armenian tiara behind, coupled with the inscription in Latin 'Armenia Conquered by Antony' refers to Antony's victories in Armenia. The reverse preserves a rather unflattering diademed bust of Cleopatra VII, the last Ptolemaic queen. Cleopatra is proclaimed on this coin as 'Queen of Kings and her sons, Kings'. Weight 3.55 g. Diameter 1.8 CM., *The Barber Institute Coin Collection, R809.*

Right, below
98. Bronze drachm of Emperor Trajan, mint of Alexandria. The reverse depicts the Serapeion, the temple of Serapis in Alexandria, with the statue of the god inside. Diameter 2.95 CM., *The Barber Institute Coin Collection, R160.*

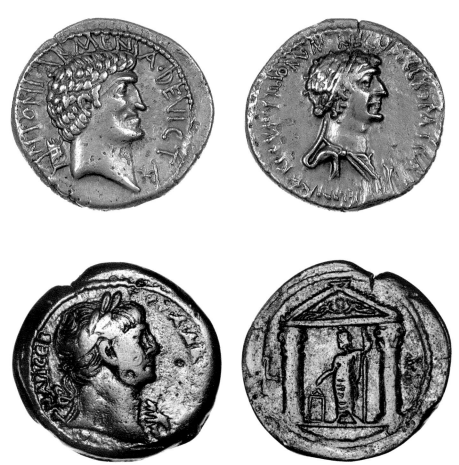

world's first university and attracted such luminaries in the fields of mathematics, geography and astronomy as Euclid, Archimedes, Eratosthenes and Hipparchos. Under royal patronage the library grew into the biggest and most important research centre of the ancient world. In that great learning environment the architect Sostratus of Knidos designed for Ptolemy II a monumental lighthouse at the entrance of the port of Alexandria. The Pharos, an edifice about 120 metres high, dressed in white marble and decorated with sculpture, was topped by a lantern with a giant bonfire whose light, possibly focused by mirrors, was projected into a beam visible from far away. The size of the lighthouse and the power of the beam were so legendary that the monument was proclaimed by ancient authors as one of the Seven Wonders of the World, and graced the iconography of several coin series minted in Alexandria during the Roman period. The lighthouse was still in use at the time of the Arab conquest of Egypt in the seventh century, but was hit by earthquakes in 692, 1303 and 1323. In 1349 the Arab

traveller Ibn Battuta commented on the ruinous state of the building, and in 1480 the Mamluk sultan Ashraf Qa'itbay erected a fort on the same spot, reusing parts of its original building material. Religion was for the Ptolemies an equally important part of their political agenda. Ptolemy III (*reg* 246–222 BC) commissioned a magnificent temple for Serapis, the God Osiris-Apis of the Egyptians.[6] The cult of Serapis became very popular during the Hellenistic and Roman period, and both Serapis and his temple in Alexandria made frequent appearances on Roman coins struck in Alexandria from the first century AD into the third (figs. 98 and 101). The middle of the first century BC found Egypt under the joint rule of eighteen-year-old Cleopatra VII (*reg* 51–30 BC) and her younger brother Ptolemy XIII. Egypt's financial troubles, the debasement of its silver currency, dynastic intrigues and growing insecurity in the face of Rome's expansionary policy prompted Cleopatra VII to seek close links first with Julius Caesar and later Mark Antony. Her country was saved, though only for twenty years. In 30 BC, three years after his fleet was defeated by Octavian at Actium, Mark Antony committed suicide and Cleopatra followed him shortly after, preferring death to the humiliation of being paraded in Octavian's triumph. Her death marked the end of Ptolemaic rule and the beginning of Egypt's life as a Roman province. The historical and fictional portrait of Cleopatra, part of western romantic literature, music and cinematography, will always intrigue those interested in knowing what the last Ptolemaic queen actually looked like, and the ways in which she manipulated her public image. An blue glass cameo (1st century BC), now in the collections of the British Museum, shows the young and attractive Cleopatra as a Greek and Egyptian queen (fig. 99). Her dress and hairstyle are typical Greek, while the triple *ureus* (three cobras in attack position) on her head, the symbol of Egyptian kingship, projects her image as ruler of Upper and Lower Egypt.[7] Cleopatra must have had less say regarding the portrait of her created by an unknown Roman die-cutter for the coins of Mark Antony (fig. 97). There she appears distinctly middle-aged and unattractive, perpetuating the age-old question, 'what is beauty?'

Above

99. Blue glass cameo with depiction of Cleopatra VII, 1st century BC. Height 1.3 CM., *British Museum, AN36919001.*

107

Below

100. Silver denarius of Emperor Hadrian (*reg* AD 117–38), struck in Rome. The reverse shows the personification of Egypt reclining, her left hand resting on a basket, her right one holding *sistrum*. At her feet there is an ibis. Diameter 1.8 CM., *The Barber Institute Coin Collection, R1133.*

Opposite

101. Billon tetradrachms of Emperor Antoninus Pius (*reg* AD 138–161) struck in Alexandria. The reverse of each coin celebrates aspects of the religious life and sources of wealth in Roman Egypt. The depiction of Serapis on coin RE269 acknowledges the importance of that Hellenistic-Egyptian god across the Roman Empire, and his temple, the Serapeion, which was an important landmark in Alexandria. The reverse of coin RE301 makes reference to Egypt's source of agricultural wealth, the River Nile, who appears reclining on a crocodile. Diameter 2.45 CM., *The Barber Institute Coin Collection, RE269;* Diameter 2.5 CM., *The Barber Institute Coin Collection, RE301.*

Roman Egypt

The annexation of Egypt to the Roman Empire in 30 BC ended three hundred years of financial and monetary autonomy of the Ptolemaic kingdom. The closed monetary system practised by the Ptolemies was abolished by Roman emperors, eager to appropriate Egypt's sources of agricultural wealth and metal to fund expensive building programmes and military campaigns.[8] Tiberius (*reg* AD 14–37) fixed the silver content of the Alexandrian tetradrachms to make it conform to that of the Roman denarii, resulting in new silver tetradrachms of lower quality. Debasement of the Roman denarius under Nero (*reg* AD 54–68) and Trajan (*reg* AD 98–117) and monetary reform under Domitian (*reg* AD 81–96) did little to improve the metallic content of the Alexandrian silver coins, which under Trajan were supplemented by a great variety of bronze drachms. Trajan's successor Hadrian (*reg* AD 117–38) took an active interest in the iconography of his coinage as a whole. In the case of Egypt his interest is manifested in the reverse iconography of both his Alexandrian tetradrachms and the denarii from the mint of Rome on which he commemorated his travels in Egypt in AD 130. On the reverse of the latter, the personification of Egypt reclining on a basket and holding a sistrum alludes to the economic importance of the area for Rome and its religious wealth (fig. 100). From the reign of Marcus Aurelius (*reg* 161–80) until the currency reform of Diocletian (*reg* 284–305) in 296/7, Alexandrian silver coins suffered continuous debasement until they became indistinguishable from the bronze ones. Despite their poor metallic content the Alexandrian coins of the second and third centuries AD present an extraordinary array of iconographical motifs, all very topical and intended for circulation within the province of Egypt. Images of the river Nile offer visual references to the agricultural wealth of Egypt (fig. 101), the famous lighthouse on coins of Commodus (*reg* 180–92) displays local pride (fig. 102), while images of Serapis and Isis on coins struck in the name of Roman emperors and their wives emphasized the association of members of the imperial family with Egyptian deities (figs. 101, 103 and 104), whose cult had become very popular in the Roman empire.

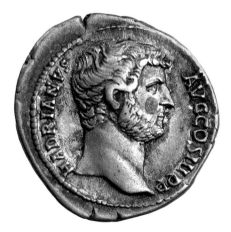
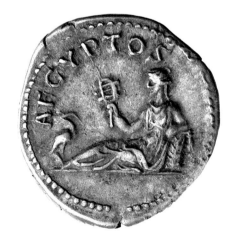

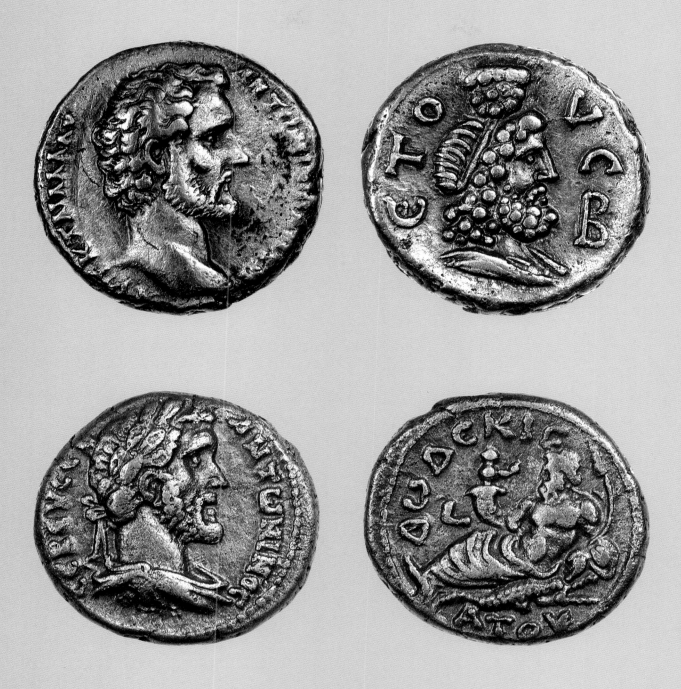

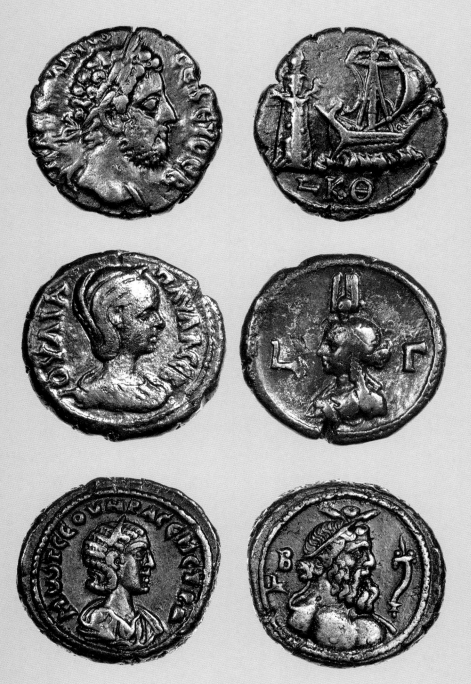

Another example of ancient Egyptian deities becoming very relevant to the life of the late Roman Empire is a fine faience plaque depicting the Egyptian god Horus, part of the Myers Collection at Eton College (fig. 105). Horus appears as a young curly haired Roman officer on horseback, spearing an ibex, the symbol of Seth, god of disorder and chaos. The image is quite a departure from the standard iconography of Horus as a falcon, falcon-headed man or child, and blends local religious tradition and Roman iconography. The only other known example that comes close to this iconography is a fourth-century example of Egyptian architectural sculpture, now in the Musée du Louvre.[9] Unlike the Myers Eton horseman, the Louvre figure, who is also dressed as a Roman officer, appears as the falcon-headed god and spears a crocodile rather than an ibex. In that respect the Myers Eton Horus is much closer to imagery encountered in contemporary Roman monumental sculpture and on coins. Equestrian statues of emperors, such as the one of Marcus Aurelius in Rome (c. AD 176), or military scenes depicted in the friezes of the triumphal arches of Titus and Constantine in Rome, convey the idea of the emperor as conqueror of Rome's enemies. Late Roman coins with similar imagery communicated this idea to a much wider audience thanks to their extensive mint output and wide circulation. Here again the emperor appears as a valiant soldier and protector of Rome, attacking his enemies or trampling them under his horse. The iconography of Horus in the Myers Eton plaque could also be linked to representations of the Holy Rider, an ancient motif whose popularity extended beyond the establishment of Christianity and can be seen on many early Byzantine bracelets (fig. 106) and amulets that clearly had an apotropaic function for their owners.[10] This idea of the mounted warrior attacking evil would eventually open the

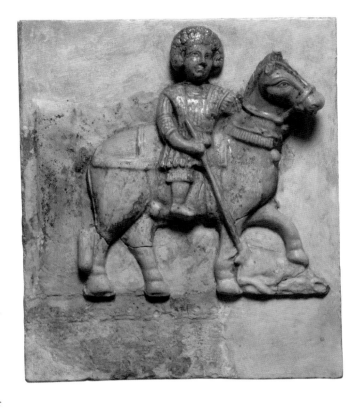

Above

105. Horus on horseback spearing Seth, faience panel, 4th century AD, 36 × 30 × 7 CM., *Myers Collection at Eton College, ECM 2166.*

Left

106. Byzantine protective bracelet made of iron, 4th–7th centuries, height 2 CM., diameter 6.5 CM. *Musée du Louvre, Département des Antiquités égyptiennes, E17352; gift of the widow of Gaston Maspero.*

107. Barbotine jar, Egypt, *c.* AD 150, 14 × 14
× 14 CM., *Myers Collection at Eton College,
ECM 2190.* The characteristic feature of this
pottery is the applied clay in various shapes
on the surface of the ware. The result is highly
decorative. The import of Barbotine ware into
Egypt prompted beautiful local imitations
such as this example.

way for the iconography of the warrior saints in Byzantium and western medieval Europe, and Horus and the ibex would find their equivalent in the representation of St George and the dragon.

Egypt's dialogue with Roman culture is also amply reflected in the local imitations generated by imported Roman pottery (fig. 107) and in new trends in art for the afterlife. These include Roman plaster mummy heads (fig. 108), a group of objects found mostly in cemeteries from between the first and third centuries AD at Arsinoe (Hawara) in the Faiyum area and at Antinoopolis, but also in Akhmim, Marina el-Alamein, the area of Thebes, Deir el-Medina and Saqqara. Portraits painted on limewood panels, sometimes attached to beautifully

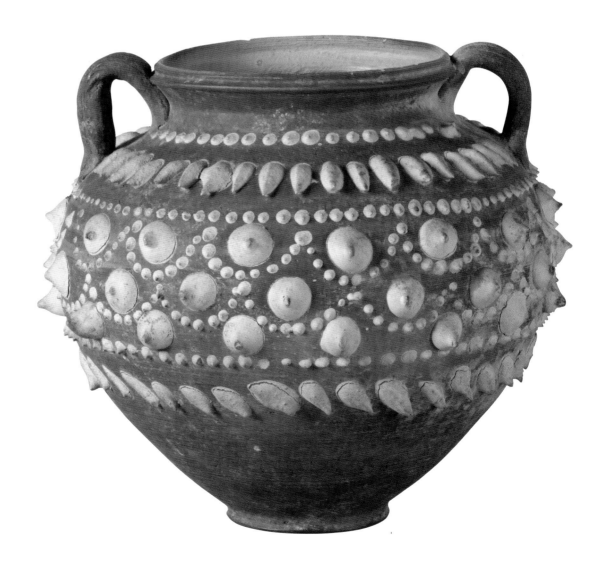

Left

108. Roman-style portrait of a deceased male, made of plaster (a mixture of sand, clay, lime and gypsum), 2nd century AD, 27 × 17 × 22 CM., *Myers Collection at Eton College, ECM 1576.*

decorated mummy cases or set into the cloth that was used to wrap the bodies, depict men, women and children dressed and coiffed in a contemporary Roman fashion. The technique used was either tempera or the more expensive and lasting encaustic one, which involved the application of heated beeswax with naturally coloured pigments to a stucco wooden surface. The result was art created on an almost industrial scale for the middle-class citizens of those cities, and more expensive art for a smaller and wealthier clientele. The mass production involved tweaking standard workshop portraits to suit the features of an individual; for wealthier clients the artists created individual portraits that have been demonstrated in some

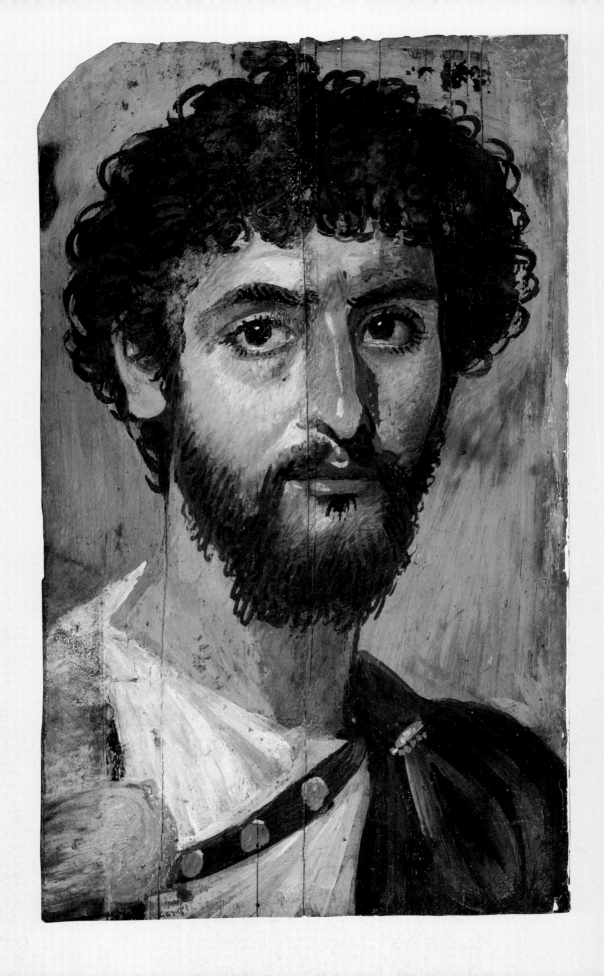

cases to bear a close resemblance to the mummified dead. The Myers Eton portrait of a man falls into the latter category owing to its skilful and very fine rendering of features (fig. 109). Some of the funerary panels depict people of a Latin or Greek appearance, while others look more Egyptian, Semitic or Nubian. The portraits reflect a Greco-Roman pictorial tradition that was adapted to Egyptian death rituals for a cosmopolitan population.[11] The sitters look extraordinarily modern, as Amelia Edwards noted:

> As we look through this ancient and interesting portrait-gallery, we cannot but recognize our kinship with these men and women, these youths and maidens, who lived and loved and died nearly two thousand years ago.[12]

Opposite
109. Portrait of a man, encaustic on limewood, c. AD 165, 41 × 24 × 1 CM., *Myers Collection at Eton College, ECM 1473*.

Below
110. Pilgrim's clay oil flask from the shrine of St Menas, 6th–7th centuries. Height 15.1 CM., width 10.9 CM., *British Museum, Department of Prehistory and Europe, 1875-10-12-16*.

Byzantine Egypt

The third and fourth centuries AD were for Egypt a period of religious and cultural change. The emergence of the Desert Fathers, the hermits, monks and ascetics who fled cities to live in poverty, solitude and prayer in the Nitrian desert (Wadi el-Natrun), is a very important chapter in the history of Christian spirituality. St Anthony, St Athanassios, bishop of Alexandria, and St Menas, martyr and miracle-worker, are just some of the many holy men associated with Egypt. The locations where they lived or were buried became *loca sancta*, places of veneration that attracted pilgrims from across the Christian world.[13] The discovery on the Isle of Wight of sixth- or seventh-century clay flasks used by pilgrims to carry oil back from the shrine of St Menas (fig. 110) testifies to pilgrimage routes between Anglo-Saxon Britain and the Byzantine-controlled eastern Mediterranean.[14] Another famous pilgrimage centre in Egypt was the monastic site at Mount Sinai. The monastery was developed by Emperor Justinian I (*reg* 527–65) around a fourth-century chapel built by Constantine I's mother Helena in honour of the Holy Bush seen by Moses. An early description of the site can be found in a travelogue composed by Egeria, a Gallic female pilgrim who visited the Holy Land between 381 and 384. The sixth-century monastery preserves a priceless collection of manuscripts and icons, the latter being among the few surviving examples of Byzantine icon painting before the iconoclastic controversy of the

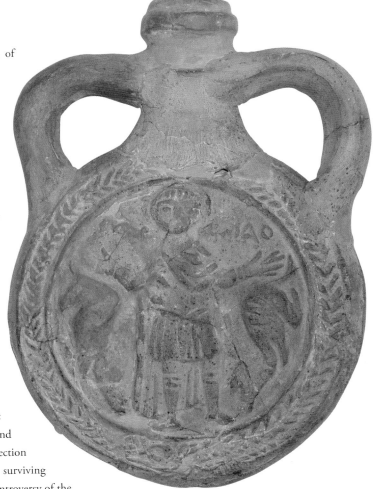

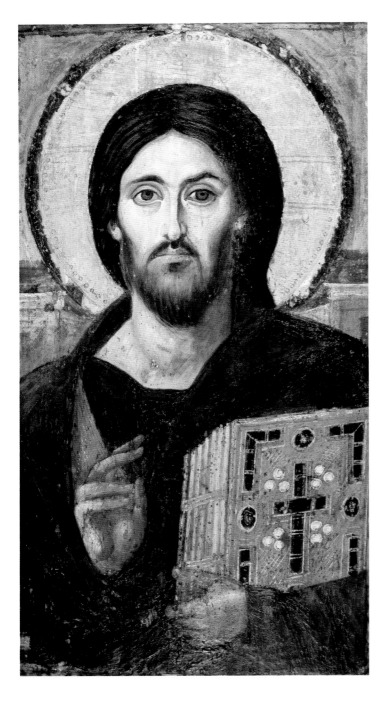

111. Icon of *Christ Pantocrator*, encaustic on limewood, 6th–7th centuries, 84.5 × 44.8 CM., *Monastery of St Catherine, Mount Sinai.*

eighth and ninth centuries. The iconographical and stylistic similarity between these sixth- and seventh-century icons (fig. 111) and the Egyptian funerary portraits from the first to the third centuries is extraordinary, and an enduring reminder of the great debt Christian pictorial art owes to the Greco-Roman tradition.

Egypt remained within the Byzantine realm until the second decade of the seventh century.[15] Throughout that period the area served as the bread-basket of the Byzantine Empire and goods were manufactured there on an almost industrial basis, greatly contributing to its economic wealth. Alexandria was the most important port of the eastern Mediterranean. The mint, whose production had been reduced by the fifth century to only the lowest copper denominations of nummi, revived in the sixth century and was active from the reign of Emperor Justin II (*reg* 565–82) until the first year of Constans II's rule (641). Its new copper coinage, unlike the standard Byzantine follis (40-nummi coin) and its denominations, was based on Egypt's old monetary system of billon tetradrachms. The values, style and iconography of these coins, minted in denominations of twelve nummi (figs. 112 and 115) and the fractions of six and three nummi, set them apart from the rest of the Byzantine copper currency. Justinian I's economic reforms of 538/9 and the introduction of the heavy follis bearing his facing bust appear to have had an impact on the production of the Alexandria mint. A new heavy multiple of the twelve-nummi coin was introduced, valued at 33 nummi (fig. 112). As for the production of gold coins, this started under Justinian I and continued with intervals until the fall of Alexandria to the Arabs in 641 (figs. 113–115). Due to their distinctive monetary values, copper coins of Alexandria mostly satisfied the needs of the internal market. When Alexandrian coins appear among coin finds in other parts of the Byzantine world their presence is connected to pilgrimage and the provisioning of Constantinople with Egyptian grain. Alexandrian coins recorded from Syria and Palestine from the reign of Justin II onwards are a reflection of the geography of transport of people and commodities that linked Alexandria to those areas in the second half of the sixth century and the early seventh.[16] The city, far from being only a major port for incoming and outgoing traffic, also became a hotbed of religious

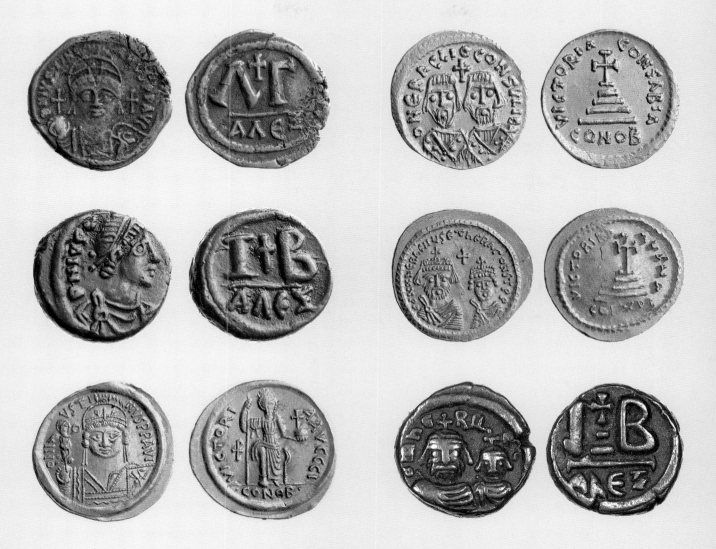

Top, left and middle, left

112. Copper 33-nummi coin of Emperor
Justinian I, and 12-nummi coin of Emperor
Justinian I, both mint of Alexandria.
Diameters 3 CM. and 1.5 CM., *The Barber
Institute Coin Collection, B923 and B926.*

Bottom, left

113. Gold solidus of Justin II, mint of
Alexandria. Diameter 2 CM., *The Barber
Institute Coin Collection, B1541.*

Top, right

114. Gold solidus of Herakleios, struck in
Alexandria in 608 during his revolt against
Emperor Phocas. The two frontal facing
bearded busts belong to Herakleios and his
father. Diameter 1.9 CM., *The Barber Institute
Coin Collection, B2706.*

Middle, right and bottom, right

115. Gold solidus and copper 12-nummi coin
of Herakleios, both struck in Alexandria.
The inclusion on the obverse of both coins
of Herakleios Constantine, the son of
Herakleios, publicizes him as co-emperor.
Diameter 2.2 CM., *The Barber Institute Coin
Collection, B2749; Diameter 1.6 CM., The
Barber Institute Coin Collection, B3517.*

116. The Liturgy of St Basil according to the Coptic Monophysite Church. The 19th-century manuscript is divided into two columns, the first of which is in Coptic and the second in Arabic. All the rubrics are in Arabic.
237 leaves, 23.4 × 16.2 CM., *The Mingana Collection, The University of Birmingham Special Collections, Mingana Chr. Arab. 9.*

violence and controversy, marked by the expulsion of its Jewish population in 415 and the alienation of its local Church from that of Constantinople following the condemnation of the Monophysites at the fourth Ecumenical Council of 451. It was in that context that the Coptic Church of Egypt developed and the important part it has played in Egypt's social and religious life and art for the last 1,500 years is testimony to its vitality (fig. 116). In 618/19 Byzantine Egypt was overrun by the Persians. After a spell of Byzantine reoccupation (628/9–39), Alexandria, the second most important city in the Empire after Constantinople, fell to the armies of 'Amr ibn al-'As in 641; the conquest of Egypt was complete by 646. In the early years of the conquest the new masters of Egypt made effective use of Byzantine administrative structures, including the technological and artistic knowhow of the mint of Alexandria. The first Islamic coins struck in Alexandria are based on Byzantine prototypes, and in themselves provide a fascinating commentary on patterns of cultural continuity and change in seventh-century Egypt.[17]

Endnotes

1 On the interrelationship between the Minoans, Mycenaeans and Egypt, see B. J. Kemp and R. S. Merrillees, with a chapter by Elmar Edel, *Minoan Pottery in Second Millennium Egypt* (Mainz, 1980); V. Hankey and D. Aston, 'Mycenaean Pottery at Saqqara: Finds from Excavations by the Egypt Exploration Society of London and the Rijksmuseum Van Oudheden, Leiden, 1975–1990', in J. B. Carter and S. P. Morris, eds, *The Ages of Homer: A Tribute to Emily Townsend Vermeule* (Austin, TX, 1995), pp. 67–92; L. Schofield and W. V. Davies, eds, *Egypt, the Aegean and the Levant: Interconnections in the Second Millenium BC* (London, 1995); L. Steele, 'Egypt and the Mediterranean World', in T. Wilkinson, ed., *The Egyptian World* (London, 2007), pp. 459–75.

2 W.D.E. Coulson, *Ancient Naukratis*, II: *The Survey at Naukratis and Environs*, pt 1 (Oxford, 1996); A. Leonard, Jr, 'Ancient Naukratis: Excavations at a Greek Emporium in Egypt. Part I: The Excavations at Kom Ge'if', *Annual of the American Schools of Oriental Research*, LIV (1997) [whole issue]; A. Möller, *Naukratis: Trade in Archaic Greece*, Oxford Monographs on Classical Archaeology (Oxford, 2000).

3 On the administration and economy of Ptolemaic Egypt, see R. Bagnall, *Hellenistic and Roman Egypt: Sources and Approaches* (Aldershot, 2006); J. Bingen, *Hellenistic Egypt: Monarchy, Society, Economy, Culture* (Cambridge, 2007); S. von Reden, *Money in Ptolemaic Egypt: From the Macedonian Conquest to the End of the Third Century BC* (Cambridge, 2007).

4 O. Mørkholm, *Early Hellenistic Coinage: From the Accession of Alexander to the Peace of Apamea (336–188 BC)*, ed. P. Grierson and U. Westermark (Cambridge, 1991).

5 P. E. Stanwick, *Portraits of the Ptolemies: Greek Kings as Egyptian Pharaohs* (Austin, TX, 2002).

6 On the Egyptian Osiris-Apis and the Greek Serapis see M. Bommas, *Heiligtum und Mysterium. Griechenland und seine Ägyptischen Gottheiten* (Mainz am Rhein, 2005) pp. 24–9.

7 S. Walker and P. Higgs, eds, *Cleopatra of Egypt* (London, 2001).

8 On the coinage of Roman Alexandria see J.G. Milne, 'Pictorial Coin-Types at the Roman Mint of Alexandria', *The Journal of Egyptian Archaeology*, XXIX (1943), pp. 63–6; J.W. Curtis, 'Pictorial Coin Types at the Roman Mint of Alexandria: a Third Supplement', *Journal of Egyptian Archaeology*, XLI (1955), pp. 119–20; S. Handler, 'Architecture on the Roman Coins of Alexandria', *American Journal of Archaeology*, LXXV/1 (1971), pp. 57–74; J. G. Milne and C. M. Cray, *Catalogue of Alexandrian Coins in the Ashmolean Museum* (London, 1971, revised version of the 1933 edition and with new types added 1933–71 by C. M. Cray); E. Christiansen, *The Roman Coins of Alexandria: Quantitative Studies*, 2 vols (Aarhus, 1988). The economic and monetary situation in fourth-century Egypt is discussed by R. Bagnall in *Currency and Inflation in Fourth Century Egypt*, BASP Supplements, 5 (Atlanta, GA, 1985). I would like to thank N. Hampartumian, Honorary Keeper of Coins at the Barber Institute, for sharing his knowledge and expertise on the coinage of Roman Egypt.

9 Musée du Louvre, Département des antiquités égyptiennes, E 4850. On the object see J. P. Digard, ed., *Chevaux et cavaliers arabes dans les arts d'Orient et d'Occident* (Paris, 2002), p. 20 and n. 22.

10 On the holy rider in late Antiquity see C. Bonner, *Studies in Magical Amulets, chiefly Graeco-Egyptian* (Ann Arbor and London, 1950); G. Vikan, 'Holy Rider' in A. Kazhdan, ed., *The Oxford Dictionary of Byzantium* (Oxford, 1991); M. Mackintosh, *The Divine Rider in the Art of the Western Roman Empire* (Oxford, 1995); J. Elsner, *Imperial Rome and Christian Triumph: The Art of the Roman Empire, AD 100–450* (Oxford, 1998); M. Saxby, 'Transcendent Power: Equestrian Iconography on Coins and Other Media in Antiquity to AD 705', MA thesis, University of Birmingham, 2009.

11 E. Doxiadis, *Portraits de Fayoum: Visages de l'Egypte ancienne* (Paris, 1995); S. Walker, 'Mummy Portraits in their Roman Context', in M. L. Bierbrier, ed., *Portraits and Masks: Burial Customs in Roman Egypt* (London, 1997), pp. 1–6; S. Walker, ed., *Ancient Faces: Mummy Portraits from Roman Egypt*, exh. cat., Metropolitan Museum of Art, New York (New York, 2000); S. Walker, 'Painted Hellenes: Mummy Portraits from Late Roman Egypt', in S. Swain and M. Edwards, eds, *Approaching Late Antiquity: The Transformation from Early to Late Empire* (Oxford, 2004), pp. 310–26; D. Monserrat, 'Death and Funerals in the Roman Fayoum', in Bierbrier, ed., *Portraits and Masks*, pp. 33–44; A.J.N.W. Prag, 'Proportion and Personality in the Fayum Portraits', *British Museum Studies in Ancient Egypt and Sudan*, 3 (2002), pp. 55–63.

12 See A. B. Edwards, 'Portrait Painting in Ancient Egypt', *Pharaohs, Fellahs and Explorers* (London, 1891), pp. 70–112.

13 A. Papaconstantinou, *Le culte des saints en Égypte des Byzantins aux Abbassides: L'apport des sources papyrologiques et épigraphiques grecques et coptes* (Paris, 2001).

14 A. Harris, *Byzantium, Britain and the West: the archaeology of cultural identity AD 400–650* (Stroud, 2003), pp. 68–9; E. Georganteli and B. Cook, *Encounters: Travel and Money in the Byzantine World* (London, 2006), pp. 13–14.

15 On Byzantine Egypt, see G. Rouillard, *L'admnistration civile de l'Égypte byzantine* (Paris, 1928); A. K. Bowman, *Egypt after the Pharaohs, 332 BC–AD 642* (Rugby, 1986); R. S. Bagnall, ed., *Egypt in the Byzantine World, 300–700* (Cambridge, 2007).

16 E. J. Prawdzic-Golemberski and D. M. Metcalf, 'The Circulation of Byzantine Coins on the South-Eastern Frontiers of the Empire', *Numismatic Chronicle*, ser. 7, no. 3 (1963), pp. 83–92; A. Wamsley, 'Coin Frequencies in Sixth and Seventh Century Palestine and Arabia: Social and Economic Implications', *Journal of the Economic and Social History of the Orient*, XLII/3 (1999), pp. 326–50.

17 A. J. Butler, *The Arab Conquest of Egypt and the Last Thirty Years of the Roman Dominion* (Oxford, 1902); P. M. Sijpesteijn, 'The Arab Conquest of Egypt and the Beginning of Muslim Rule', in Bagnall, ed., *Egypt in the Byzantine World*, pp. 437–55.

About the Contributors

Martin Bommas studied Egyptology, Classical Archaeology and Near Eastern Archaeology at the Universities of Heidelberg and Leiden. From 1994 to 2001 he was Research Fellow at the Egyptology Institute of the University of Heidelberg, from where he received his PhD in 2000. In 2001 he became Assistant Professor at the University of Basel before he was appointed Senior Lecturer in Egyptology at the University of Birmingham in 2006. He excavated in Pakistan and led several archaeological projects as a field director for the German Archaeological Institute, Cairo, at Elephantine between 1990 and 2009. Apart from Birmingham, he has lectured on Egyptology at the Universities of Heidelberg, Basel, Zurich, Roma Tre, Venice and Sheffield. He has published widely on religious texts, architecture and archaeology in English, German and Italian.

Eurydice Georganteli studied Archaeology and History of Art at the Aristotle University of Thessaloniki and the University of Oxford. She has held scholarships at the Universities of Oxford and Cambridge, and has been Fellow in Byzantine Studies at Dumbarton Oaks, and at the Clore Leadership Programme in Cultural Management. Eurydice has worked for the Hellenic Ministry of Culture and taught at the University of Thessaly, Volos, before becoming the Barber Institute Curator of the Coin Collection and Lecturer in Numismatics and Economic History at the University of Birmingham in 2000. She has been a Visiting Lecturer at the AHRB Centre for Byzantine Cultural History at Queen's University, Belfast, and contributes to the MBA programme of the University of Birmingham Business School. Her book *Encounters: Travel and Money in the Byzantine World* (London 2006) in co-authorship with Barrie Cook was the recipient of the 2007 Royal Numismatic Society Lhotka Memorial Prize.

Maria Michela Luiselli studied Egyptology and Ancient Near Eastern Studies at the University of Rome 'La Sapienza'. After two years at the School of High Specialization in Ancient Near Eastern Archaeology (focusing on Egyptology) at the same University, she started her PhD in Egyptology on ancient Egyptian personal piety at the Ägyptologisches Seminar of the University of Basel, supported by a Fellowship from the Italian Government. In 2006 she was appointed post-doctoral Research Fellow for the Swiss National Competence Centre for Research 'Iconic Criticism'. Since 2008 she has been Honorary Research Fellow in Egyptology at the University of Birmingham, where she also lectures on ancient Egyptian religion and art. As an epigraphist, she has worked for several Italian and German archaeological missions in Egypt. Her publications focus mainly on Egyptian religion, art and literature.

Michael Sharp is Senior Commissioning Editor for Classics and Byzantine Studies at Cambridge University Press. He studied Classics and Ancient History at Corpus Christi College, Oxford, writing his doctoral thesis on 'The Food Supply in Roman Egypt', and has held a British Academy Postdoctoral Fellowship at the University of Reading, as well as teaching positions at Hobart and William Smith Colleges, Geneva, NY, and Christ Church, Oxford. He has published several chapters in edited volumes on villages, food supply and taxation in Roman Egypt.

Select Bibliography

Alston, R., *The City in Roman and Byzantine Egypt*
(London and New York, 2002)

Ashton, S.-A., *Ptolemaic Royal Sculpture from Egypt:
the Interaction between Greek and Egyptian Traditions*
(Oxford, 2001)

Assmann, J., *Death and Salvation in Ancient Egypt*, trans.
D. Lorton (Ithaca, NY, and London, 2005)

Aubert, M.-F., and R. Cortopassi, *Portraits de l'Egypte romaine*
(Paris, 1998)

Bagnall, T. S., and B. W. Frier, *The Demography of Roman Egypt*
(Cambridge, 1994)

Bierbrier, M. L., *The Tomb Builders of the Pharaohs*
(London, 1982)

Bolman, E. S., ed., *Monastic Visions: Wall Paintings in
the Monastery of Saint Antony at the Red Sea*
(New Haven, CT, 2002)

Cameron, A., *The Mediterranean World in Late Antiquity,
AD 395–600* (London, 1993)

Capasso, M., *Introduzione alla papirologia*
(Bologna, 2005)

Capuani, M., et al., *Christian Egypt: Coptic Art and Monuments
through Two Millennia* (Collegeville, MN, 2002)

Clarysse, W., and D. J. Thompson, *Counting the People in
Hellenistic Egypt*, 2 vols (Cambridge, 2006)

Cormack, R., *Painting the Soul: Icons, Death Masks and Shrouds*
(London, 1997)

Curl, J.S., *Egyptomania: The Egyptian Revival, a Recurring Theme
in the History of Taste* (Manchester and New York, 1994)

Depauw, M., *A Companion to Demotic Studies* (Brussels, 1997)

d'Auria, S., P. Lacovara and C. H. Roehrig, eds, *Mummies and
Magic: the Funerary Arts of Ancient Egypt* (Boston, 1988)

David, R., *Conversations with Mummies: New Light on the Lives
of Ancient Egyptians* (London, 2000)

Drower, M. S., *Flinders Petrie: a Life in Archaeology*
(London, 1985)

Eliade, M., *The Sacred and the Profane: The Nature of Religion*
(Orlando, FL, 1987) [this translation is based on the
German translation of the French original]

el-Shahwy, A., *The Funerary Art of Ancient Egypt: a Bridge to
the Realm of the Hereafter* (Cairo, 2005)

Faulkner, R. O., *The Ancient Egyptian Coffin Texts*, 3 vols
(Warminster, 1973)

—, *The Ancient Egyptian Pyramid Texts* (Oxford, 1969)

Faulkner, R. O., and O. Goelet, *The Ancient Egyptian Book of
the Dead: The Book of Going Forth by Day; The First
Authentic Presentation of the Complete Papyrus of Ani*
(San Francisco, 1994)

Frankfurter, D., *Pilgrimage and Holy Space in Late Antique Egypt*
(Leiden, 1998)

—, *Religion in Roman Egypt: Assimilation and Resistance*
(Princeton, NJ, 1999)

Fraser, P., *Ptolemaic Alexandria* (Oxford, 1972)

Grajetzki, W., *Burial Customs in Ancient Egypt:
Life in Death for Rich and Poor* (London, 2003)

Hayes, J. W., *Late Roman Pottery: A Catalogue of Roman
Fine Wares* (London, 1972)

Hornung, E., *The Ancient Egyptian Books of the Afterlife*,
trans. D. Lorton (London, 1999)

Ikram, S., and A. Dodson, *The Mummy in Ancient Egypt:
Equipping the Dead for Eternity* (Cairo, 1998)

Kitzinger, E., *The Cult of Images in the Age before Iconoclasm*
(Washington, DC, 1954)

Lichtheim, M., *Ancient Egyptian Literature: A Book of Readings*,
3 vols (Berkeley, CA, 1973–80)

McDowell, A., *Village Life in Ancient Egypt: Laundry Lists
and Love Songs* (Oxford, 1999)

Parkinson, R., *The Rosetta Stone* (London, 2005)

Pestman, P. W., *The New Papyrological Primer*
(Leiden, 1994)

Pinch, G., *Votive Offerings to Hathor* (Oxford, 1993)

Rathbone, W. W., *Economic Rationalism and Rural Society in
Third Century AD Egypt* (Cambridge, 1991)

Rawlandson, J. *Landowners and Tenants in Roman Egypt:
the Social Relations of Agriculture in the Oxyrhynchite
Nome* (Oxford, 1996)

Rees, J., *Amelia Edwards: Traveller, Novelist and Egyptologist*
(London, 1998)

Reeves, N., *Ancient Egypt: the Great Discoveries*
(London, 2000)

Roberts, C. H., and T. C. Skeat, *The Birth of the Codex*
(Oxford, 1987)

Sadek, A. I., *Popular Religion in Egypt during the New Kingdom*,
HÄB 27 (Hildesheim, 1987)

Sarris, P., *Economy and Society in the Age of Justinian*
(Cambridge, 2006)

Shaw, I., and P. Nicholson, *The British Museum Dictionary of
Ancient Egypt* (London, 1995)

Stevens, A., *Private Religion at Amarna: The Material Evidence*,
BAR International Series (Oxford, 2006)

Taylor, J. H., *Death and the Afterlife in Ancient Egypt*
(London, 2001)

Thomas, N., ed., *The American Discovery of Ancient Egypt*
(Los Angeles, 1995)

Toivari-Viitala, J., *Women at Deir el-Medina: A Study of
the Status and Roles of the Female Inhabitants in the
Workmen's Community during the Ramesside Period*
(Leiden, 2001)

Trilling, J., *The Roman Heritage: Textiles from Egypt and
the Eastern Mediterranean, 300–600 AD*
(Washington, DC, 1982)

Turner, E. G., *Greek Papyri:an Introduction*
(Princeton, NJ, 1968)

Walters, C. C., *Monastic Archaeology in Egypt*
(Warminster, 1974)

Wente, E. F., *Letters from Ancient Egypt* (Atlanta, GA, 1990)

Willems, H., ed., *Social Aspects of Funerary Culture in the
Egyptian Old and Middle Kingdoms: Proceedings of the
International Symposium Held at Leiden University,
6–7 June 1996* (Leuven, 2001)

Index

Page numbers in *italic* refer to picture captions.